ROAM

Drawings and Words
by Ari Targownik

Copyright © 2019 Ari Targownik
ISBN-13: 978-1-6875-5428-4

All rights reserved. No part of this book may be reproduced or used in any manner without written permission of the copyright owner.

All images are owned and were produced by Ari Targownik except where noted otherwise.

Thanks to Robert Fuller and Judith E. McCarthy for feedback, guidance, and encouragement.

Introduction

My name is Ari Targownik. I draw, I paint in oils, I've worked in the video game industry doing digital art, and sometimes I write.

This book is a collection of drawings done while on a twelve day trip to Rome in the Spring of 2019. Accompanying the drawings are writings about my experiences and thoughts during my time there.

This trip came together rather fast. I had been to Europe before and I knew the next trip would be to Rome, I just didn't know when I would go. For whatever reason I found myself mentioning this sentiment to people more and more, and once I started looking into flights, plans gelled quickly.

I'd had the idea of making this kind of book for a few years, with the general goal of showing a journey. I was initially just going to post the drawings on social media, but the thought of combining them with the writings to make *something* was more exciting. In making a book I'd be creating a self-contained piece and experience the process of doing so.

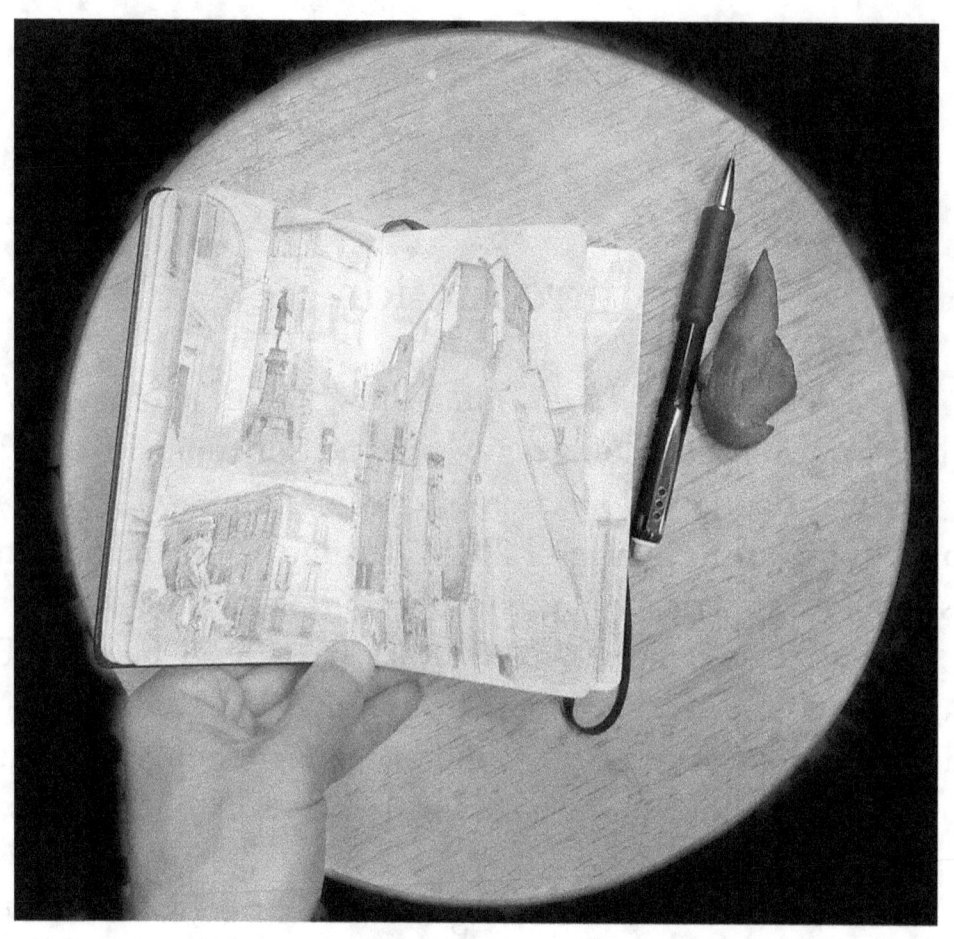

 A bit about the materials I use for sketching: The majority of drawings in this book were made with a mechanical pencil in a small sketchbook (many of the drawings are reproduced larger than their original size). Some were done with regular pencils on basic printer paper. I also used a "kneaded" eraser, which is a clay-like blob that can be molded into different shapes. A common use is to sculpt it into a small point, allowing for precision erasing.

DAY 1

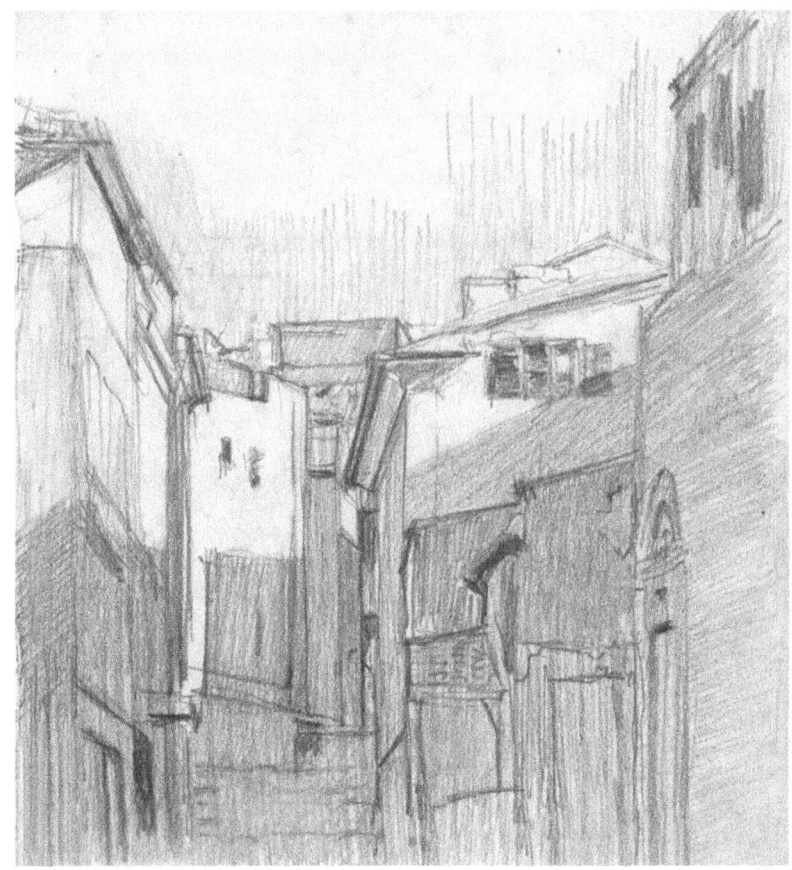

After getting settled at the hostel I rushed back out to the streets to walk, look, and when the moment caught me, draw. Since there were only a few hours of sunlight left in the day I impatiently drew this not-so-special cropping of buildings. The best rudder I have for choosing what to draw is to follow what grabs me. The most recurring aspects of this seem to be strong lines and shapes, which often manifest themselves in light, structures, and the interesting ways they interact in space.

The tricky part when picking what to draw first in a new place is that you aren't sure which kinds of scenes are scarce and which are commonplace. I assumed there were many more scenes like this one, but I drew it anyway just to get started.

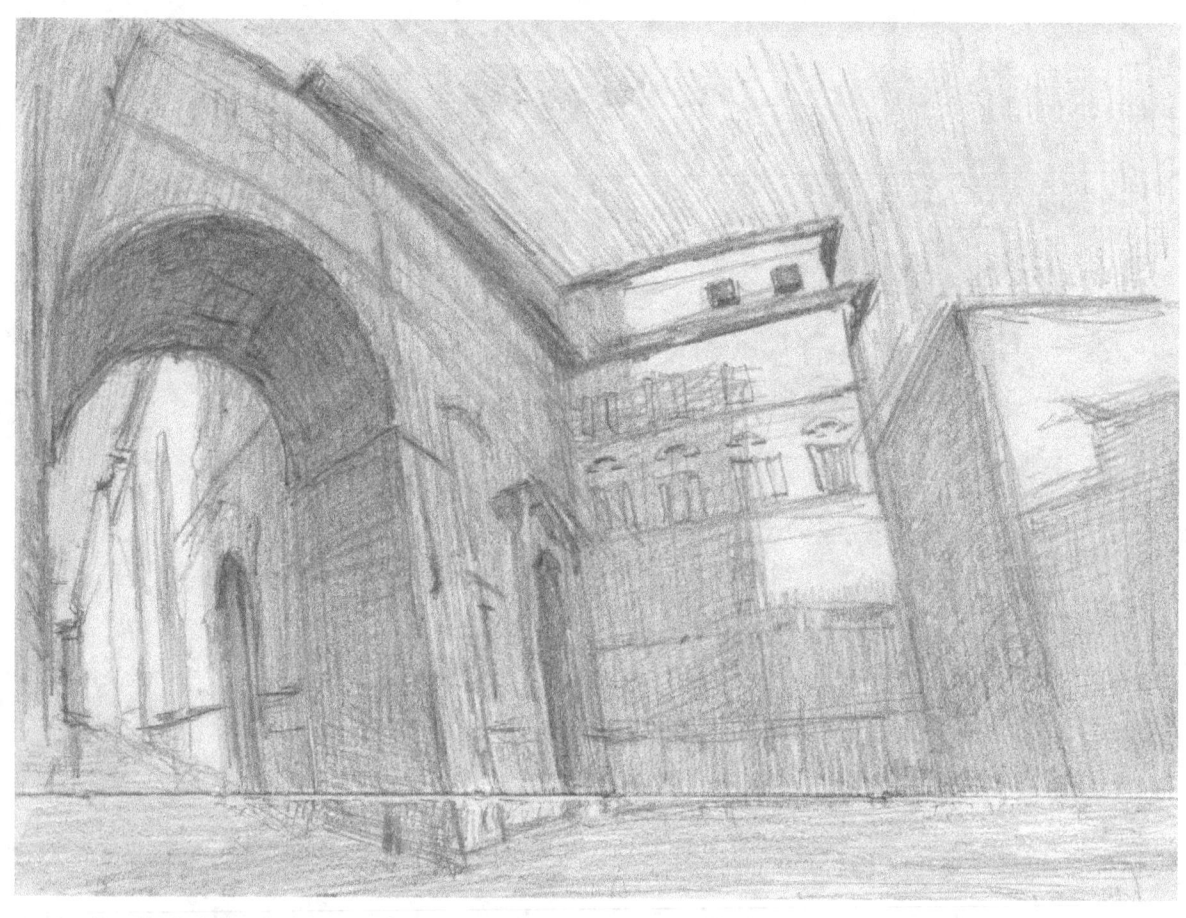

 I failed to capture the rather extreme wide-angle view I was going for from underneath this archway. As I would see throughout the trip, there are many archways in the city, all of which were tempting to draw. They often create interesting combinations of shapes.
 Scooters and sometimes cars passed through this archway, both spitting out exhaust that gets trapped and lingers in these narrow alleyways. The streets in Rome are more organically laid out than I'm used to, which, aside from the occasional fumes, are fun to explore and make for more visual excitement.

DAY II

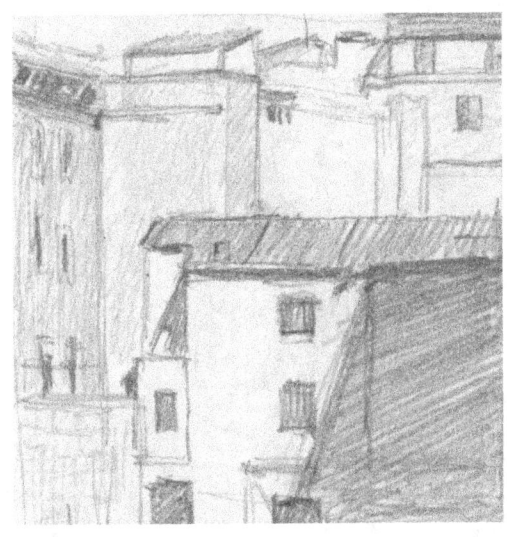

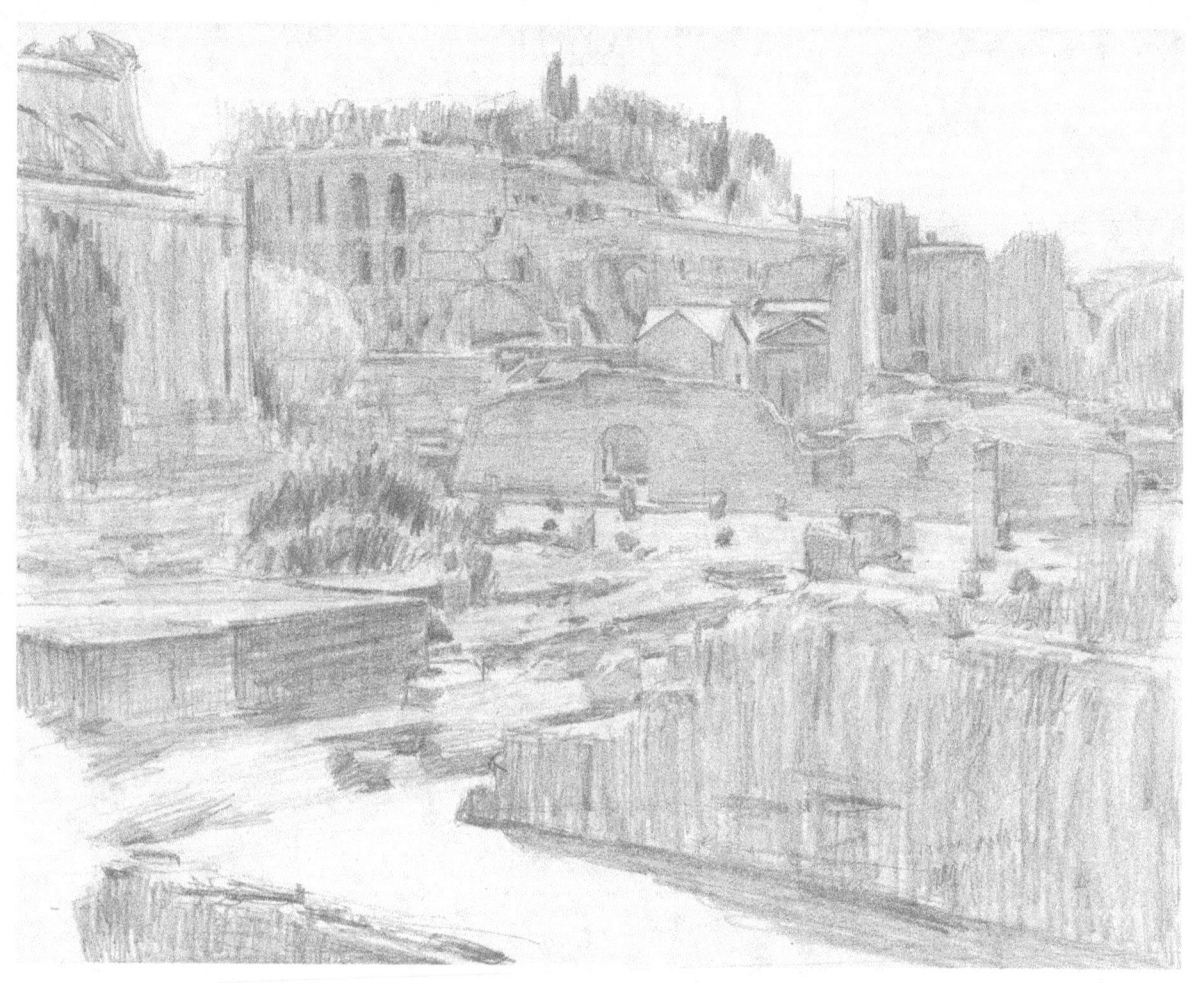

 This was a collection of ruins (called "The Forum") I saw on maps before the trip. I didn't realize you had to get a ticket, but it makes sense–it's a big slice of history and it's good to preserve it. Walking through it is a little like going back in time. It reminds me of a part in the movie *Titanic* when they are exploring the sunken ship and the movie gives brief glimpses of what it was like when it was fully operational and bustling with life.

 I wasn't initially excited to draw this scene but it had such a readily visible history that it was hard to pass up. Additionally, I sometimes like the task of drawing a lot of "stuff." Just the act of visually recording, though mechanical at times, can be pleasurable and calming for me.

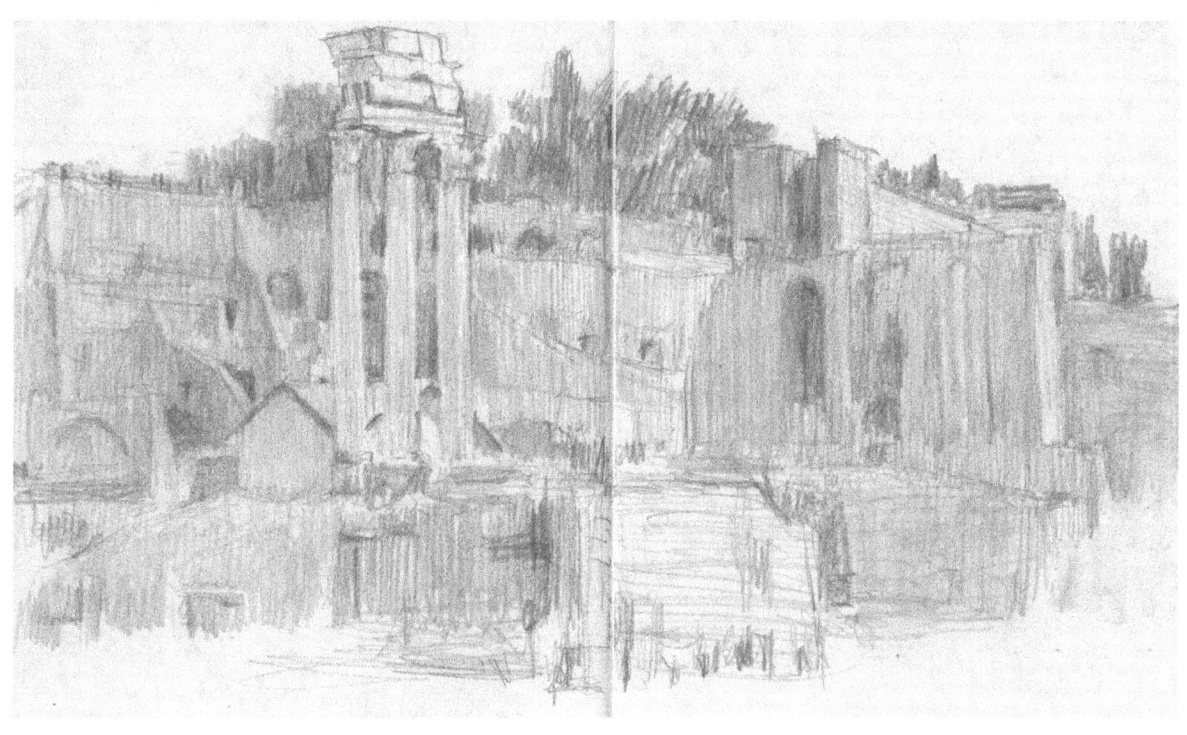

Another view of the Forum, but from inside it. Even though ancient Rome looks quite different from Paris, the similarity I see is that both places appear to be built with the intent of being impressive, whereas most modern cities are built with economy in mind. It's similar to how someone dresses, it makes an impression on the viewer, consciously and subconsciously. These ruins have an air of self-respect and pride that's very evident and lasting, despite being worn and damaged—which if anything gives them more character. I'm not suggesting we need to return to "old ways", it's a different world now, but it is a reminder that quality is resilient.

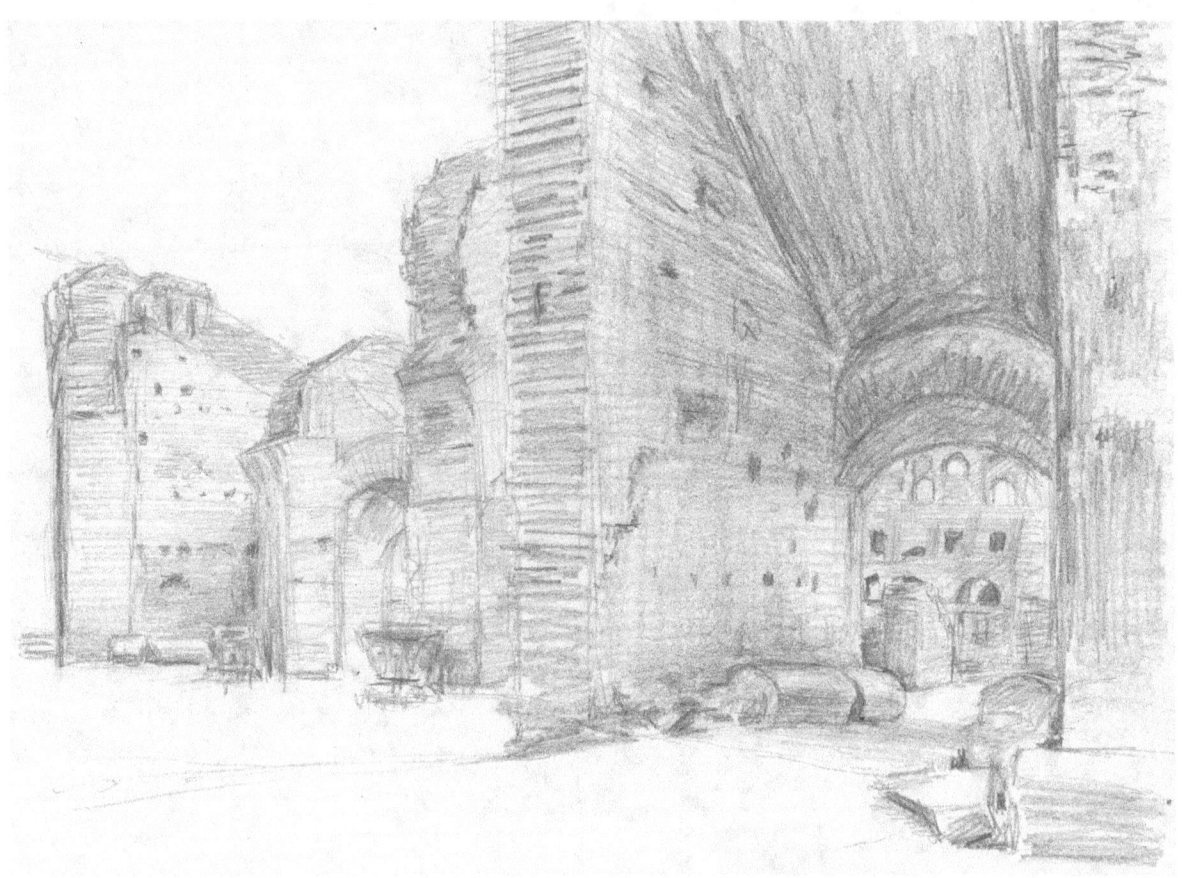

 This was sketched from inside the Colosseum, mostly as a result of idle time while sitting down to rest my feet. Much like the Forum, I wasn't particularly compelled to *draw* the Colosseum. This is not to say that it isn't special, it is. It's not as big as a modern-day football stadium but it's more impressive. Something about the scale and repetition of forms, the uninterrupted "roundness" of it, it's hard to turn your gaze away.
 What's just as bewildering is imagining what it was like when it was built. It is so damaged now that it's really a shell of its former self, and yet it has more presence (especially from the outside) than most constructions. On the inside, there is one small section where the original seats are in decent condition and you just try to picture the whole place being like that section. Fully functional, it must have been doubly astounding.

DAY III

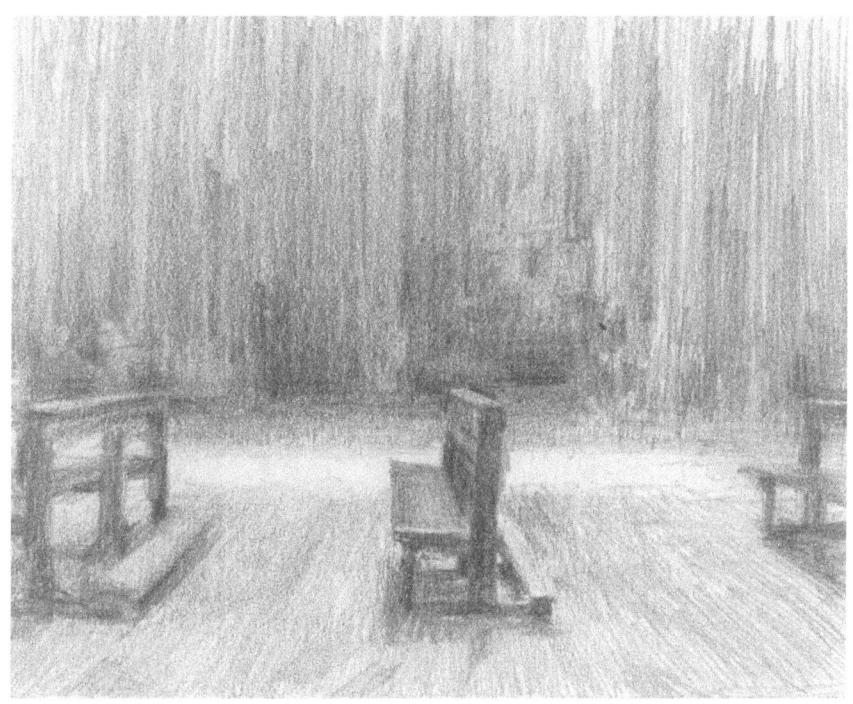

Starting this day off, the sky was overcast and it was rainy. As I wandered in a general Northern direction without much of a specific sight to see, I soon went inside the first of many impressive churches in Rome–partially out of curiosity and partially for shelter.

On the floor of the doorway was a begging woman dressed in a black robe, like something you might see in a painting or movie designed to express tragedy. Inside the church, the ceiling was noticeably high and there were paintings and sculptures all around. There was someone playing an organ with enormous pipes. The sound was powerful and arresting, scary almost. I did this drawing sitting at one of the pews while there was a

service in progress. On the one hand, I felt some guilt about sitting there whilst not observing or acknowledging the religious practice. On the other hand I was truly appreciating this place, albeit in my own way. By the time I left, the rain had stopped and the sun was coming out.

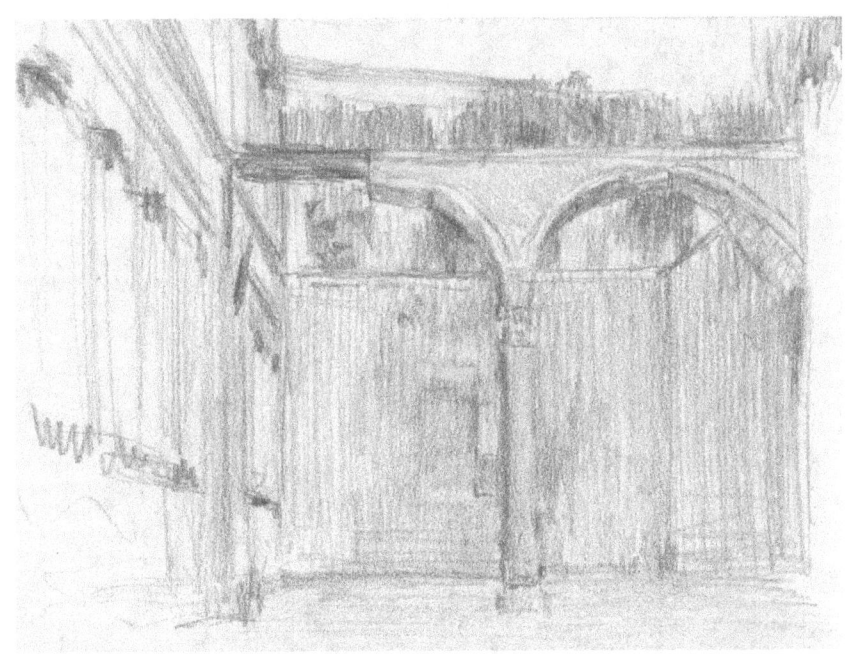

There was a pile of garbage to the left of this scene. A cat was walking through it and settled itself comfortably inside a damaged cardboard box.

The drawing on the following page is of the same scene but from the opposite side and higher up. Another cat was up there. It looked at me briefly while I was drawing and then leaped from the ledge on the left to the one in front of me. If the cat hadn't completed this leap it would have fallen down to the ground below, possibly injuring itself or worse. I wondered what role fear plays in their minds in making such a decision. I would guess the cat has done this sort of thing so many times that it's like walking to them. Animals do experience fear but they don't have the option to *think* about it and exacerbate it as we humans do–that's my take, anyway.

As I found out in the days following, cats inhabited several of the historical sites. One location had a sign explicitly stating "Do not feed the cats, they are taken care of."

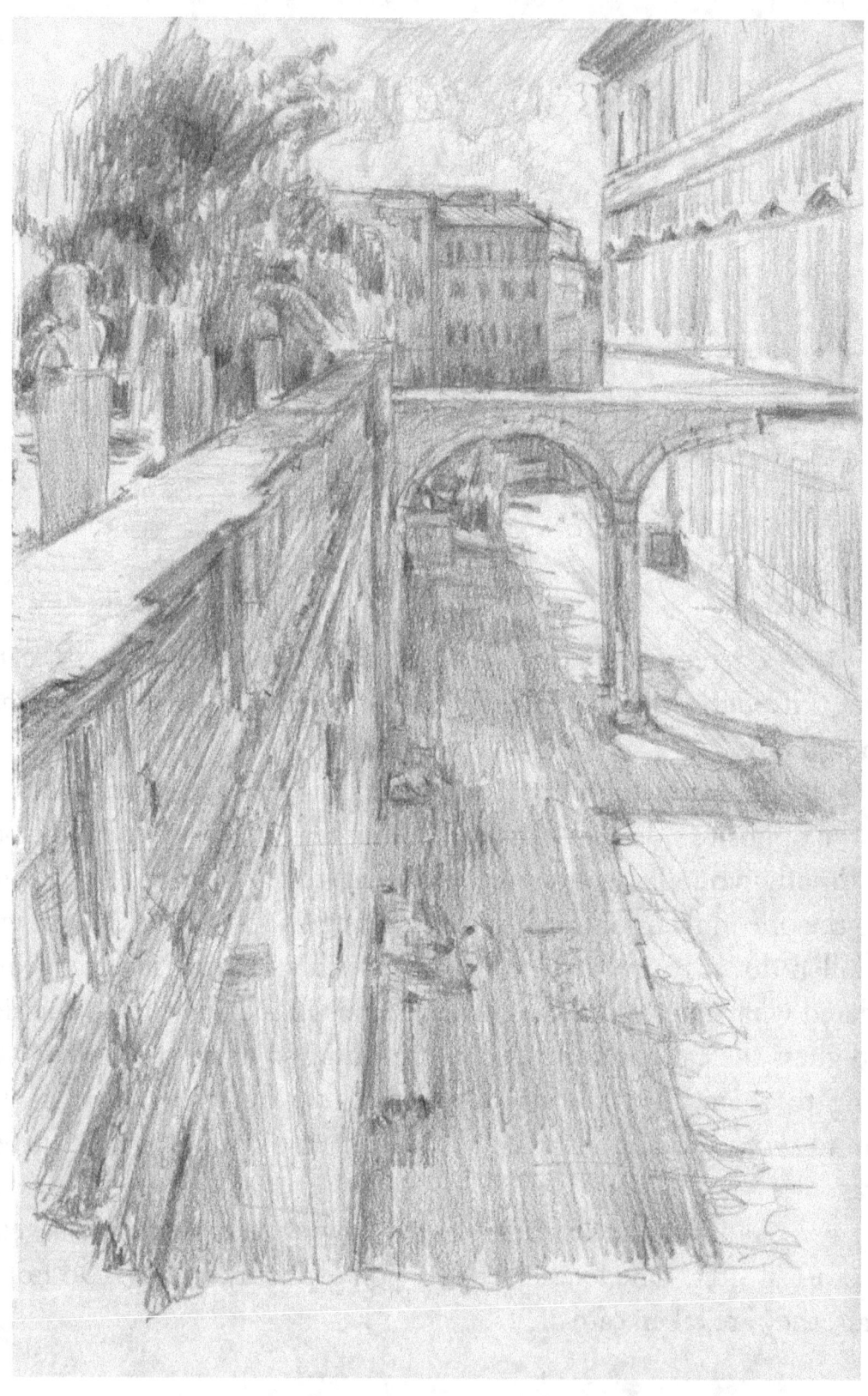

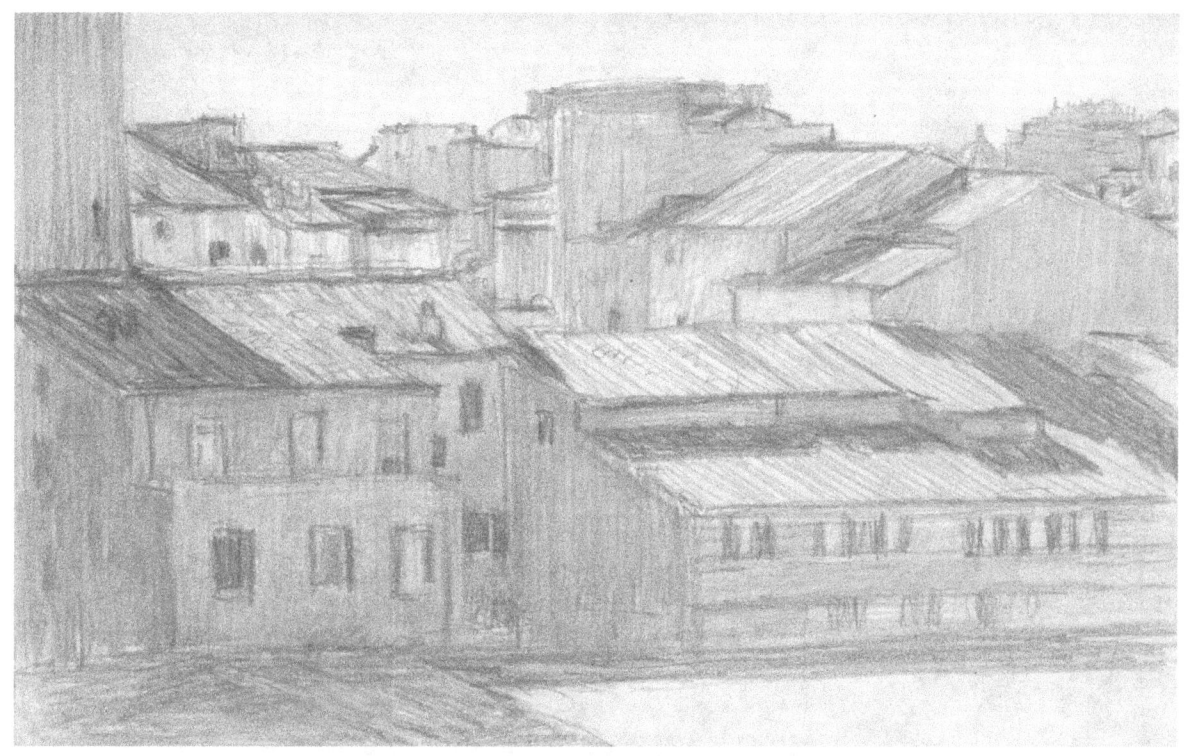

A view from a window inside a museum. I like drawing collections of buildings, even more so from higher vantage points such as this (a few stories higher would have been fantastic, so as to see the building tops recede into the horizon). The sun was strong, beaming on me through the window. It was uncomfortably hot but I didn't stop to take my jacket off–I get in a sort of trance when drawing. If I had to simply stand in these scenarios *without* drawing, it would be much harder for me to tolerate. It's really the most tangible proof I have, to myself or anyone else, that I must enjoy something about the process of drawing.

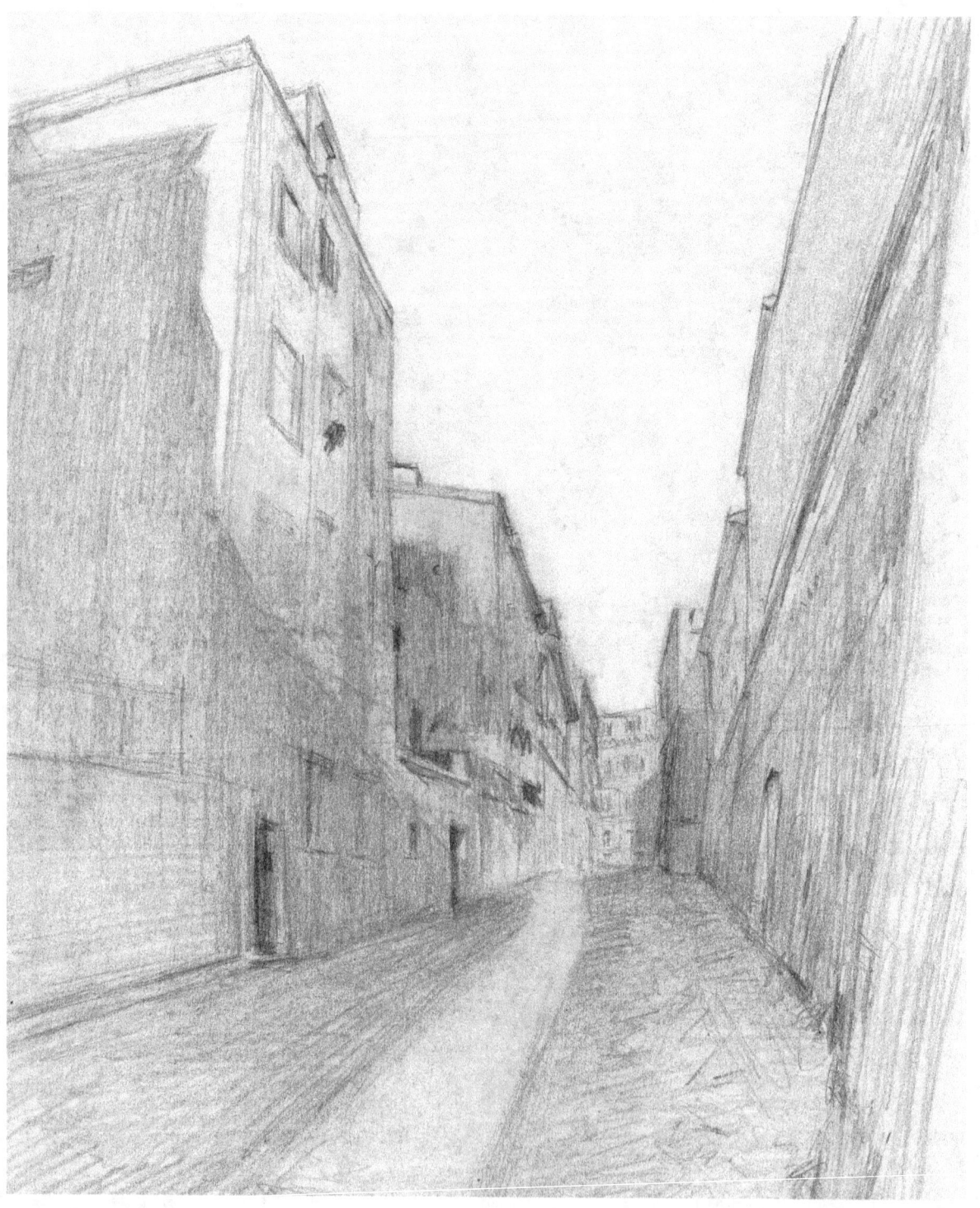

DAY IV

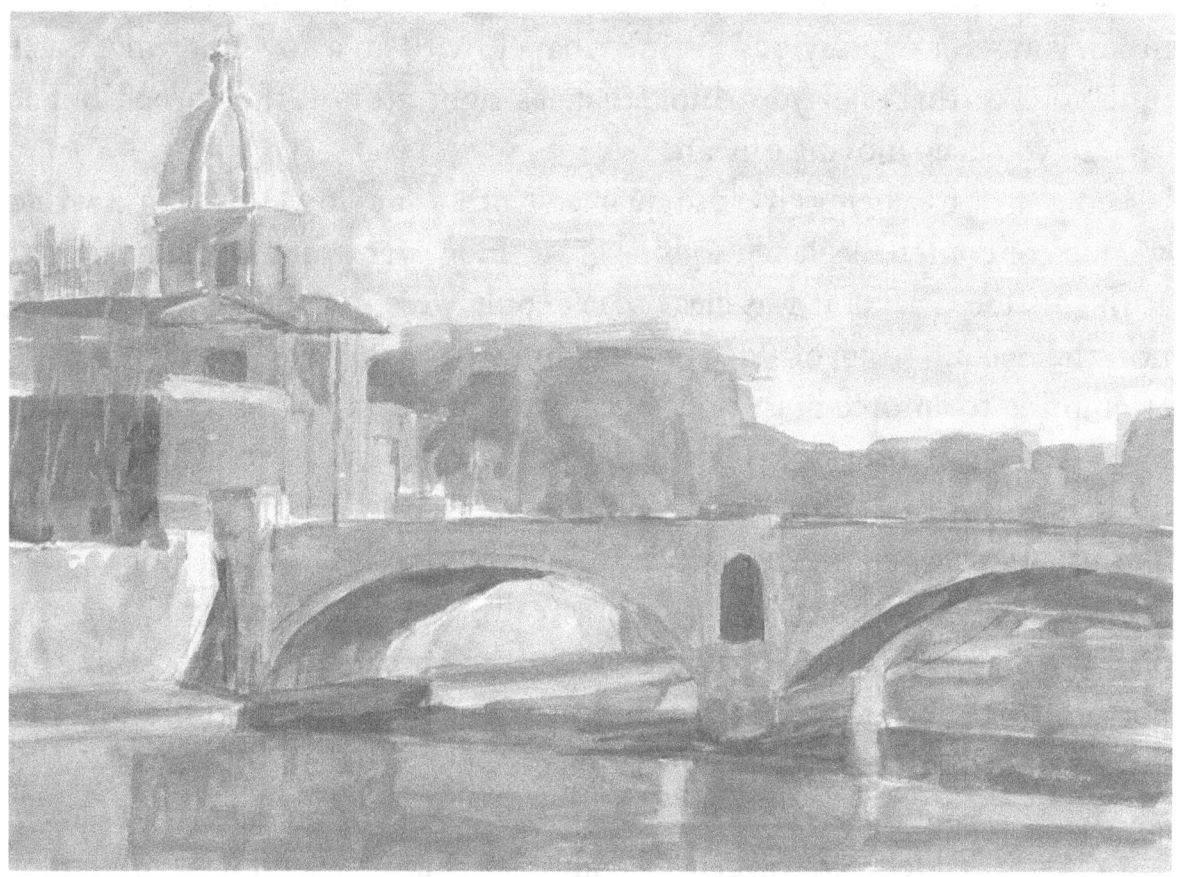

 This is the only painted piece in the book (made with gouache). This was done not long after I finished visiting the Vatican, where I saw the Sistine Chapel, the inside of the St. Peter's Basilica, and various paintings and sculptures.

 Before this trip, while researching the visit to the Vatican, I read that one is required to be silent in the Sistine Chapel and that taking pictures is prohibited. I found the "silence" rule to be interesting because you just don't see that being explicitly stated much anywhere outside of a library.

 The journey between arriving at the Vatican and actually getting into the Sistine Chapel is a long one. It's a slow-moving march of

humans plodding along from chamber, to hallway, to the next chamber, to staircase, to hallway, and so on. Along this journey, about 5 or 6 separate times, you see a sign saying "Sistine Chapel" with an arrow pointing. Each time you see that sign you think that it's right around the corner, but it isn't, so you keep moving onward.

After being in close quarters with a moving crowd for a while the idea of complete silence sounds great. However, when I finally arrived at the Sistine Chapel it was clear that people were not following this rule, nor the second rule of "no photography." There were security guards attempting to enforce both rules but it was something like a teacher trying to control a small auditorium of 6th graders. I'm certainly not innocent of misbehaving, so I guess we all have our own personal arbitrary list of places and situations where we feel respect should be given.

With that said, it didn't really stop me from enjoying the Sistine Chapel. It was interesting to see the actual scale of the thing in person. I had seen the paintings in art history books many times but you can't quite tell how big or small the images appear in real life....until you're there.

Aside from the ceiling paintings, there is also the wall mural of the Last Judgement, which I found to be surprisingly relevant. At the most basic level it's a crowd of figures that are concerned, distressed, and in turmoil. In this case, the distress is over whether they will gain entrance to heaven or not, but it could just as well be access to a big party, a concert, a flight, a rescue helicopter, etc. The painting transcends its subject matter and I connected with it in the current day. I suppose that's the essence of what we call "timeless." One could easily imagine these figures holding smartphones, desperately trying to call someone, texting, taking pictures, recording videos, and posting on social media.

DAY V

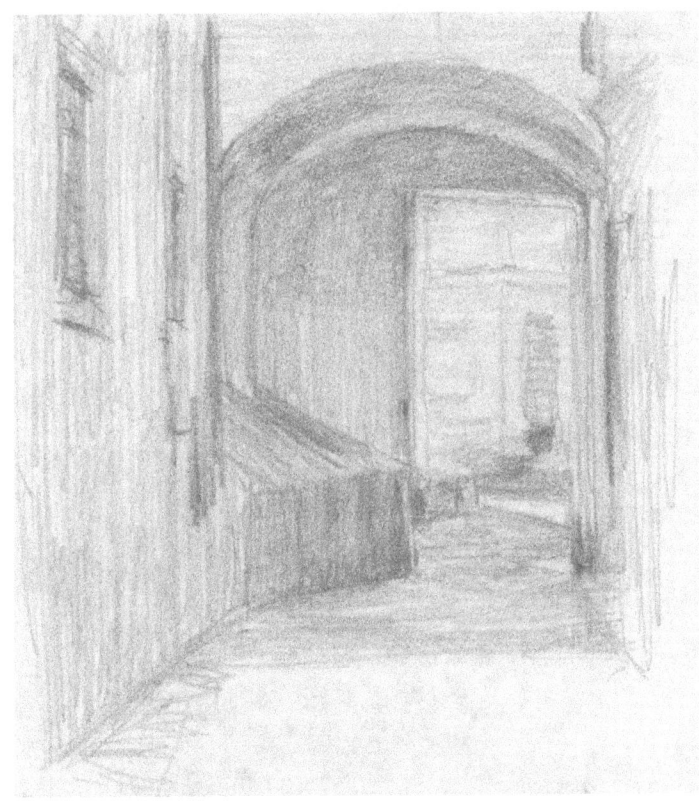

 This sketch is the opposite side of the same archway in the drawing on the following page. I'm drawn to archways, doorways, openings, etc. I think it's because they contextualize and frame the scene that lies beyond the opening. It's the notion of being in one place juxtaposed with the potential of going *somewhere else*, and through drawing it, I try to capture that feeling of curiosity and mystery of what lies beyond the opening (the unknown).

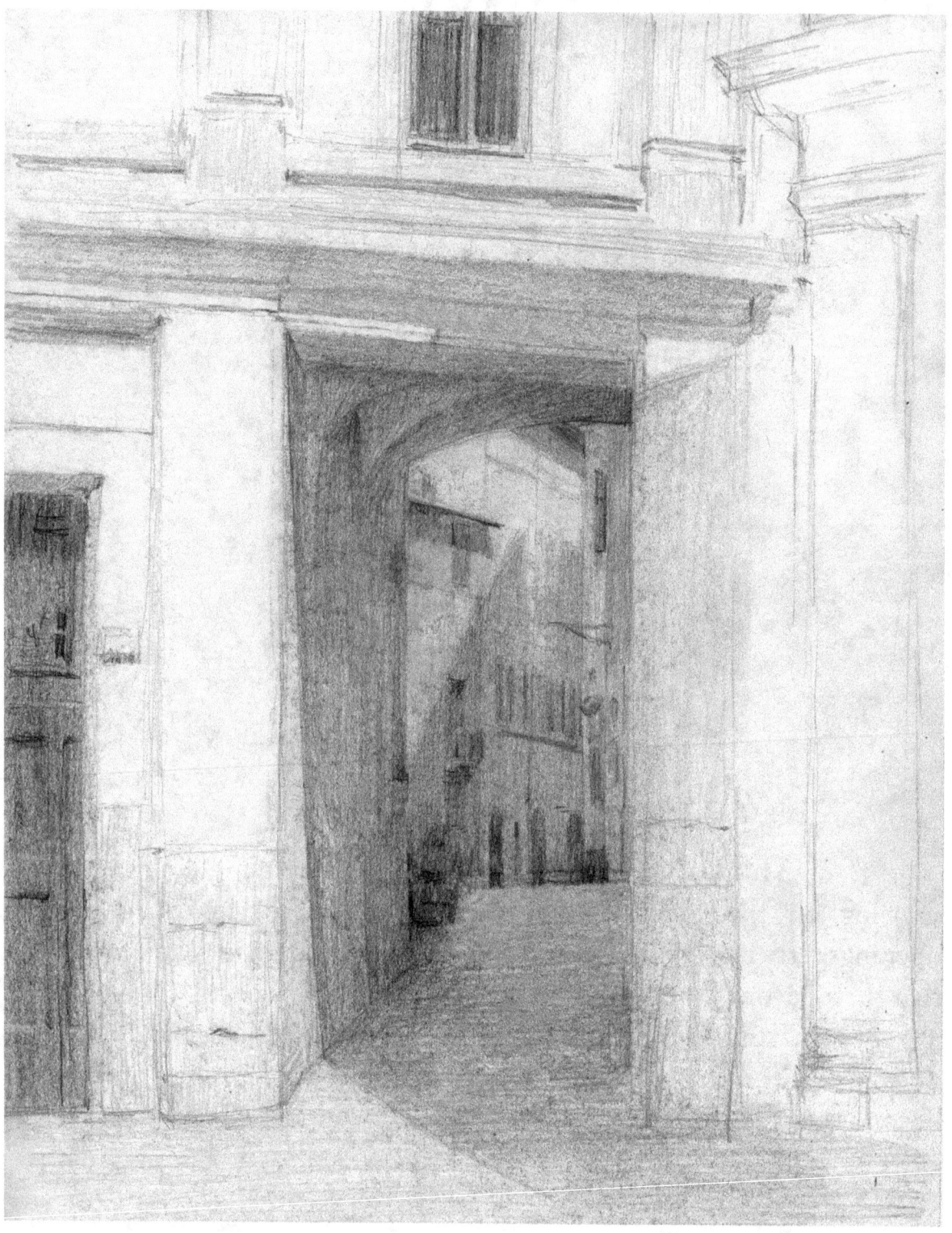

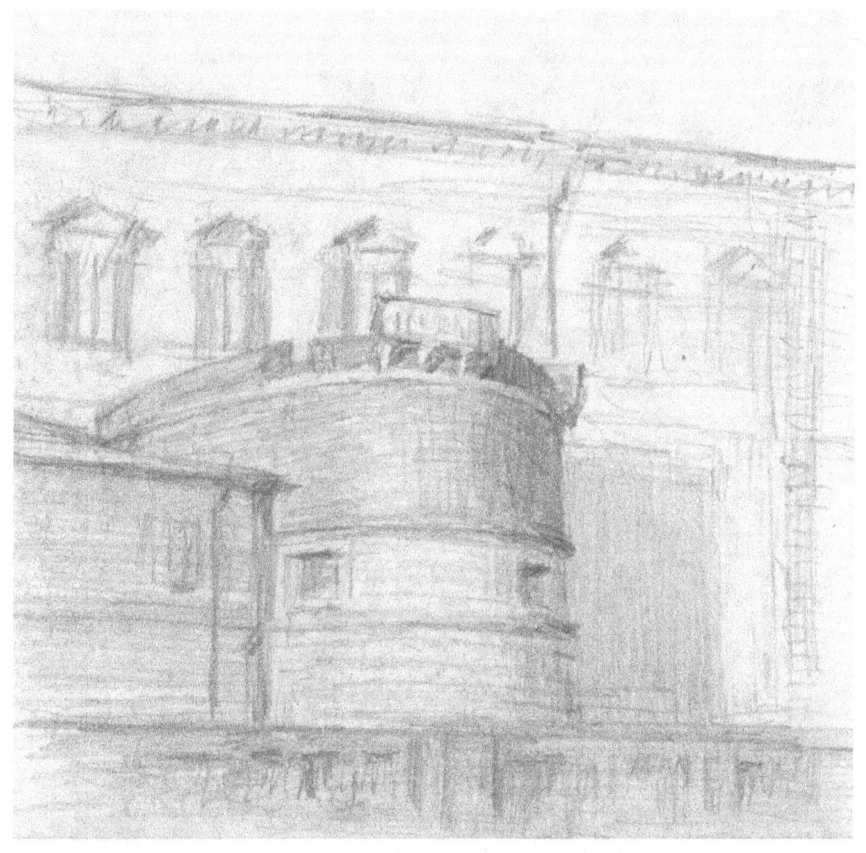

 While roaming I saw a couple yelling at each other, more specifically a man yelling at a woman. They weren't speaking English so I didn't understand what was being said. He didn't seem threatening, they just looked like a troubled couple. Soon after I came upon a plaza as the sun was setting. I sat down on a stone bench and drew this portion of a building.

 Obviously not visible here but the colors were a big reason why I liked this scene; often the case during a sunset. As for the colors in Rome in general, they're all variations of "warm"–pinks, peaches, reds, beiges, creams, oranges, yellows, ochres, etc. It seemed like the only blue thing to be found in the whole city was the sky.

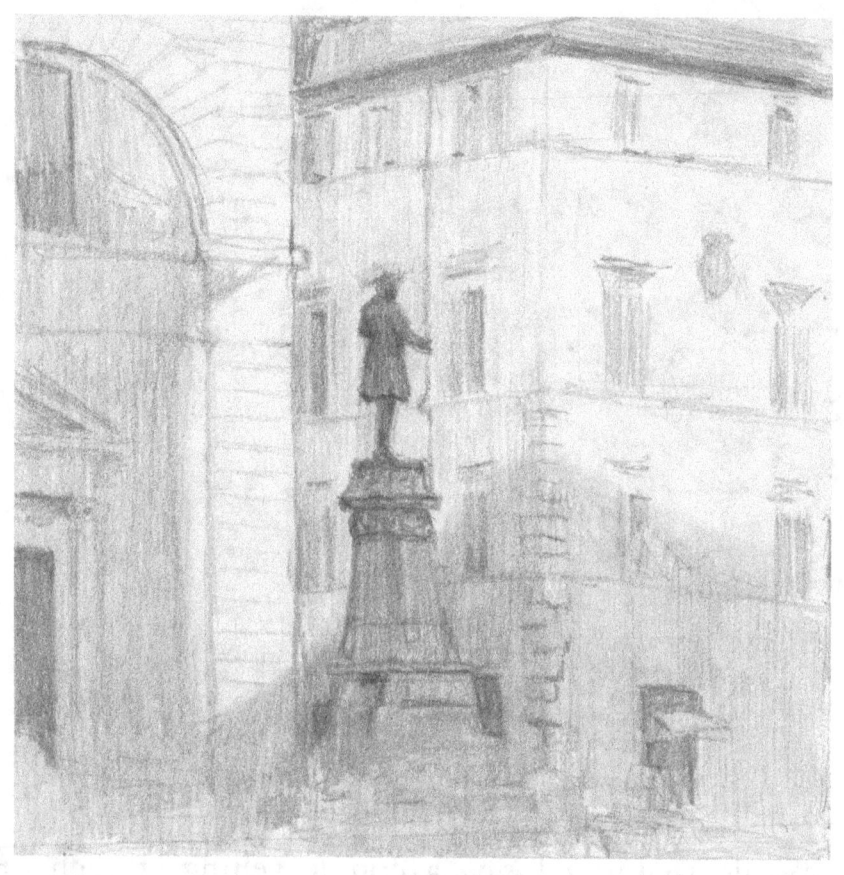

 I glanced at this scene and it captivated me enough that I stopped and walked back to draw it. This motif of a sculpture–a kind of super-human presence amid a regular city setting is something I drew several times throughout this trip. It sounds cheesy but seeing these sculptures in the city can at times make you feel like you're in a place where "gods" reside. I don't know if this was the intention of the sculptors or the city planners but these public sculptures, numerous around Rome, truly elevate the city.

While walking alongside a historical sight, a man came up to me, friendly and smiling, and shook my hand.....for some reading this, even at this point, you may be suspicious–and rightly so. An unfortunate part of traveling is that basically anybody that approaches you on the street is trying to get your money; this was my first lesson on the point.

He had a handful of leather bracelets and said he was giving me one as a gift and proceeded to put two on my wrist. I thanked him and started to walk away but then he asked for money to feed his family. I declined, said "sorry", and after trying to walk away again he asked for money again, but this time putting his hand on my arm to stop me. Feeling threatened (justifiably or not) I looked for a place where there were more people. I saw some folks gathered around a street musician and walked to them. The man followed me and insisted I give him money for the "gift" he gave me. I told him to take it back but he refused, so I forced the bracelets off–not easy to do without breaking them since he tied them with a knot. After that, he gave up and left me alone.

As I walked away from this situation I had a mix of emotions–relief, anger, and excitement. Later on though I wondered, what happens to someone that leads them to duping people, semi-threatening them, and that's just another day at the office? What series of events get somebody to that point? Not good ones I imagine, and if I had gone through them who's to say I wouldn't end up doing the same thing?

Throughout the trip I saw others pulling this same scam. I admittedly was too scared to intervene; I'm no superhero I suppose. It's easy to get emotionally carried away after such events but it's not personal, it's business–life trying to live, which doesn't always make for a pretty picture.

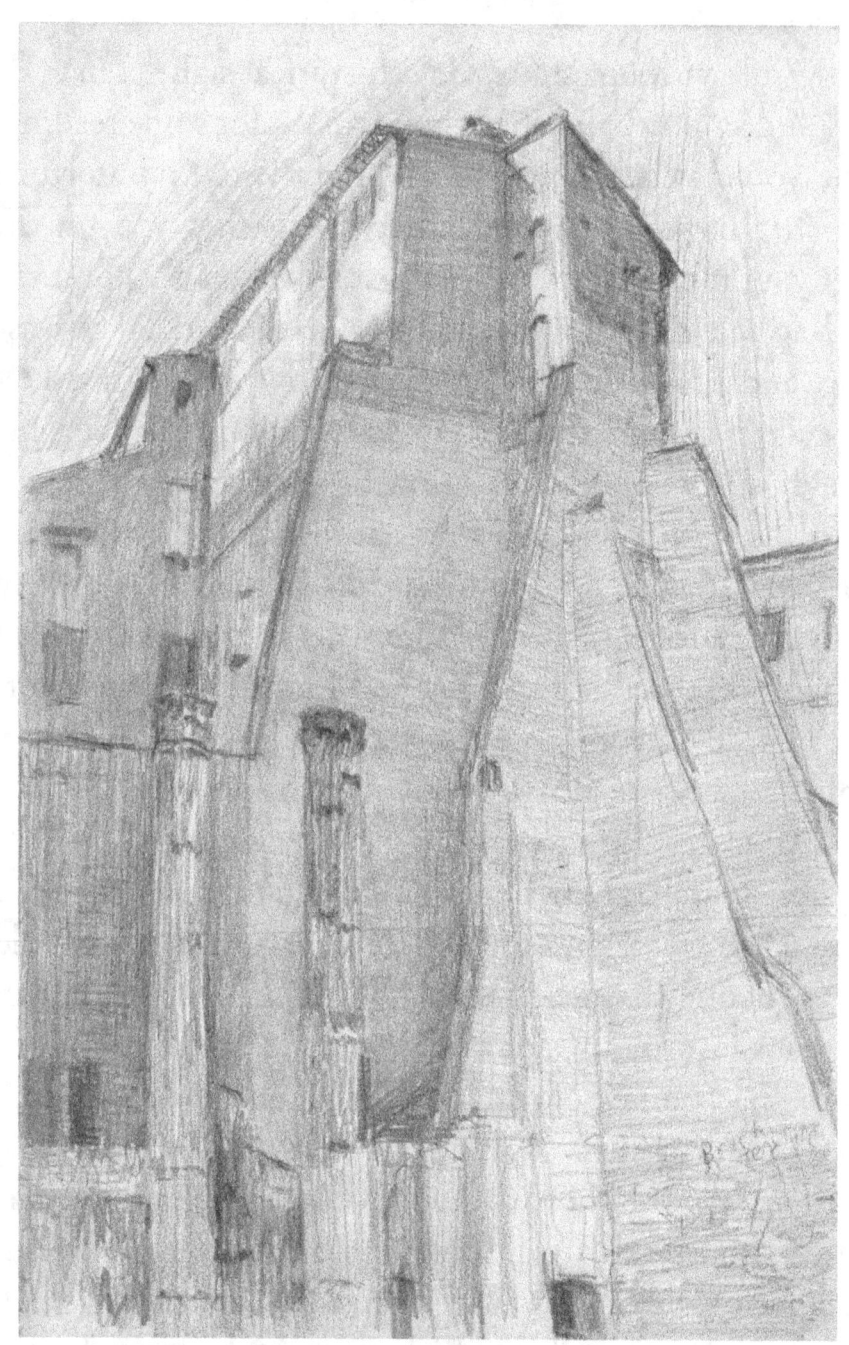

 Soon after that incident, I came upon this building. It seemed to be a modern apartment built on top of an incomplete portion of a castle or temple—an unusual combination, both for its construction and shapes.

DAY VI

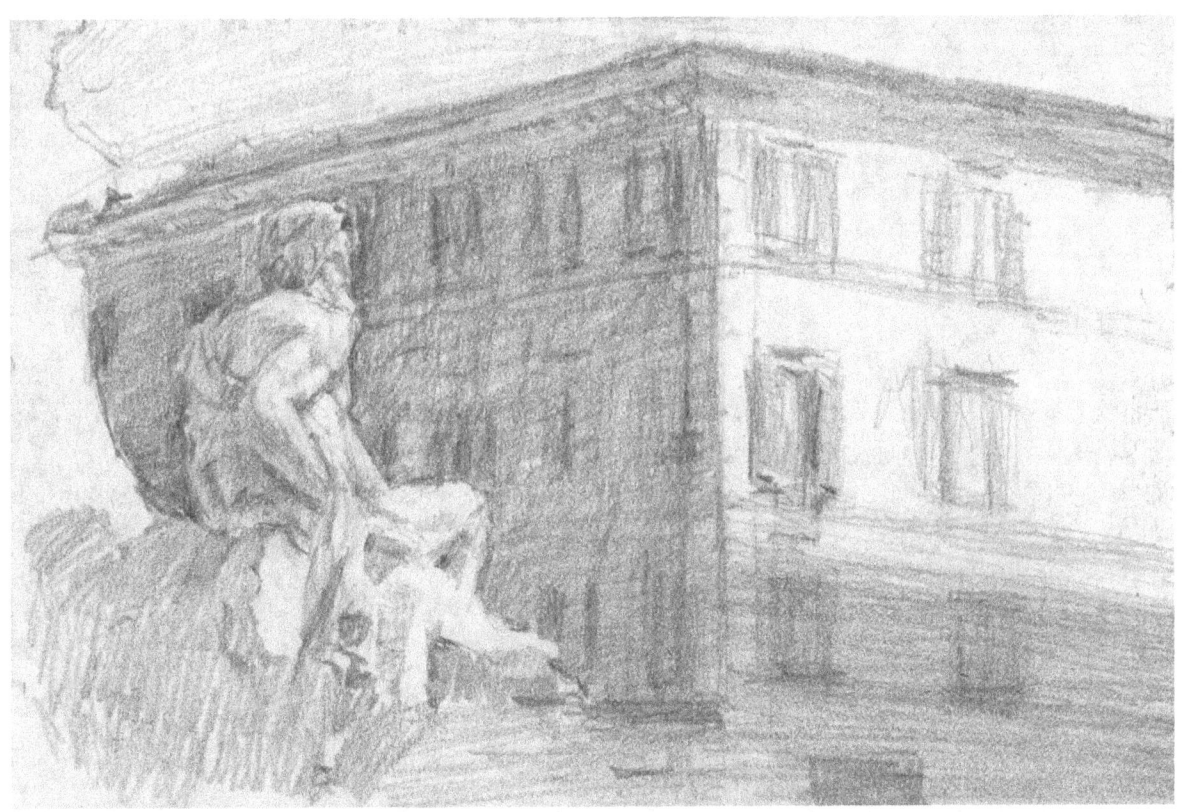

 While making this drawing someone complimented me on it and asked if he could take a picture of it. When people ask to take a picture of my work I am flattered but my heart sinks a bit. It's like the Native American belief that a photograph steals a person's soul. I feel like that when someone takes a picture of my work, but that's mostly ego.

 When I take an emotional step back it's easy to see these situations as positive ones. This is just someone who stumbled upon something interesting to them and they want to record the moment; pretty much the same thing I do when making these drawings. So I let them take the picture–my only request is that if they plan to post the image somewhere, they credit me.

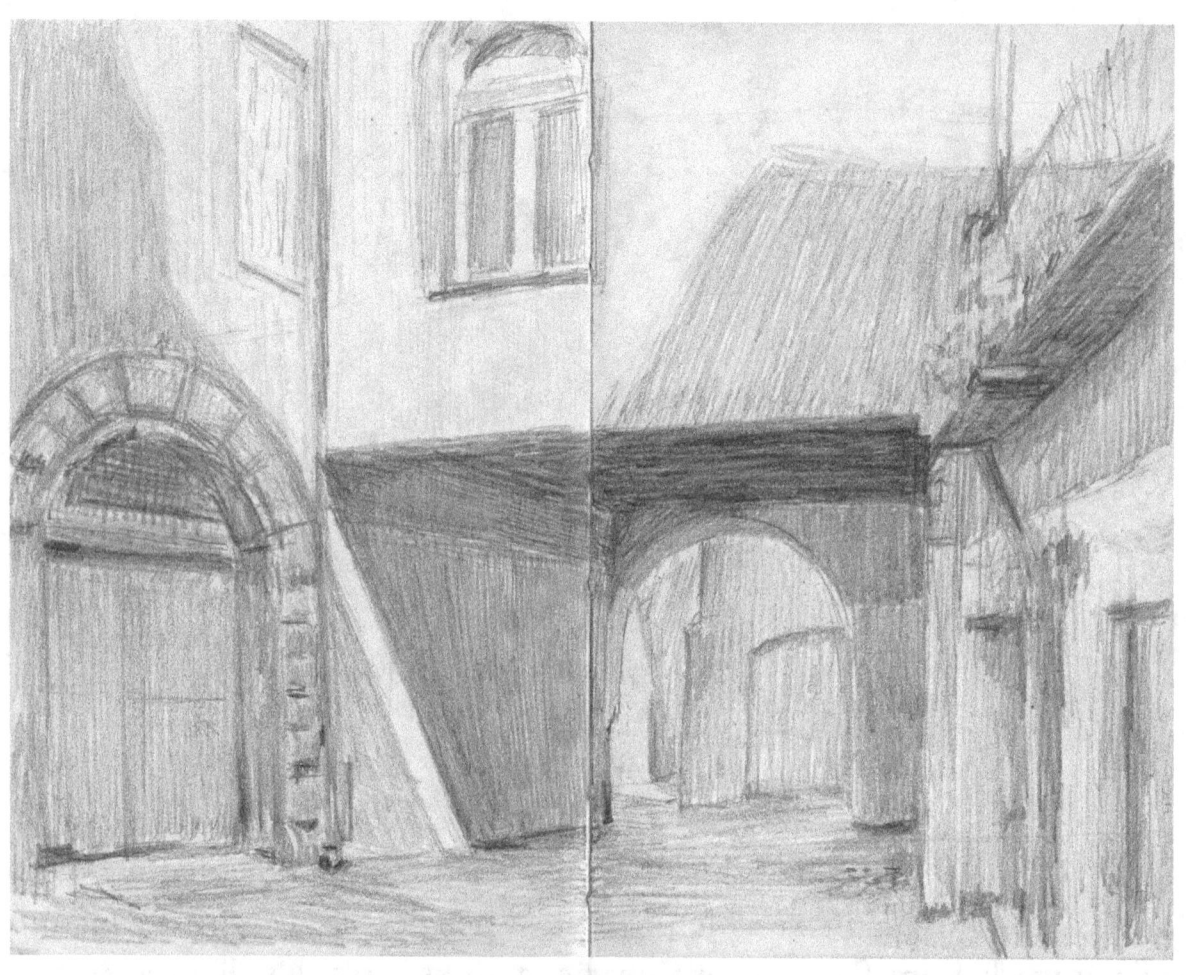

 I stumbled upon this rather secluded area, a short pathway between bigger streets. Places like this, hidden away from public noise, feel like my own private area. While drawing this, three teenagers sat on a bench behind me to talk and smoke cigarettes. I felt like they were intruding in some small way, even though they had every right to be there. Conversely, when someone showed up that actually lived in one of these buildings, I felt like *I* was the intruder.

While strolling around I saw an enormous gleaming white staircase leading up to a church and set to climb it. Upon reaching the top, the church once again served as a respite. It may not be what the builders intended, but in a way, wasn't it? Salvation is practically synonymous with relief.

This church, like so many in Rome, was filled with ridiculous amounts of detail and craftsmanship, but I couldn't help but think "this is so....much....work." I had the same thought when seeing intricate tapestries in the Vatican. The makers of these things truly must have enjoyed or gotten some satisfaction out of the process, otherwise, how would they get to that level of expertise? Even if it was just a paid job, they clearly had a proclivity towards the work.

The next two sketches were done from behind the aforementioned church. It was while drawing the first one that I noticed Rome has some great trees. You might ask, what makes a tree great? It might be easier to first explain what I think is a bad tree–it has an overall shape close to an amorphous blob, with the masses of foliage and branches being repetitious in scale and orientation. The opposite will have a distinct, unique silhouette, and will be comprised of groupings of foliage and/or branches with good variety.

The trees in Rome have distinct shapes, in some cases closer to rectangular blocks of foliage, which is more my preference. Some of the cypress trees, in particular, are very simple but strong because of their clarity and staunch verticality. To note, a tree without any leaves can be equally interesting. Leaves or no leaves, it boils down to shapes and the way they sit in relation to each other, which pretty much defines how a painting is composed as well.

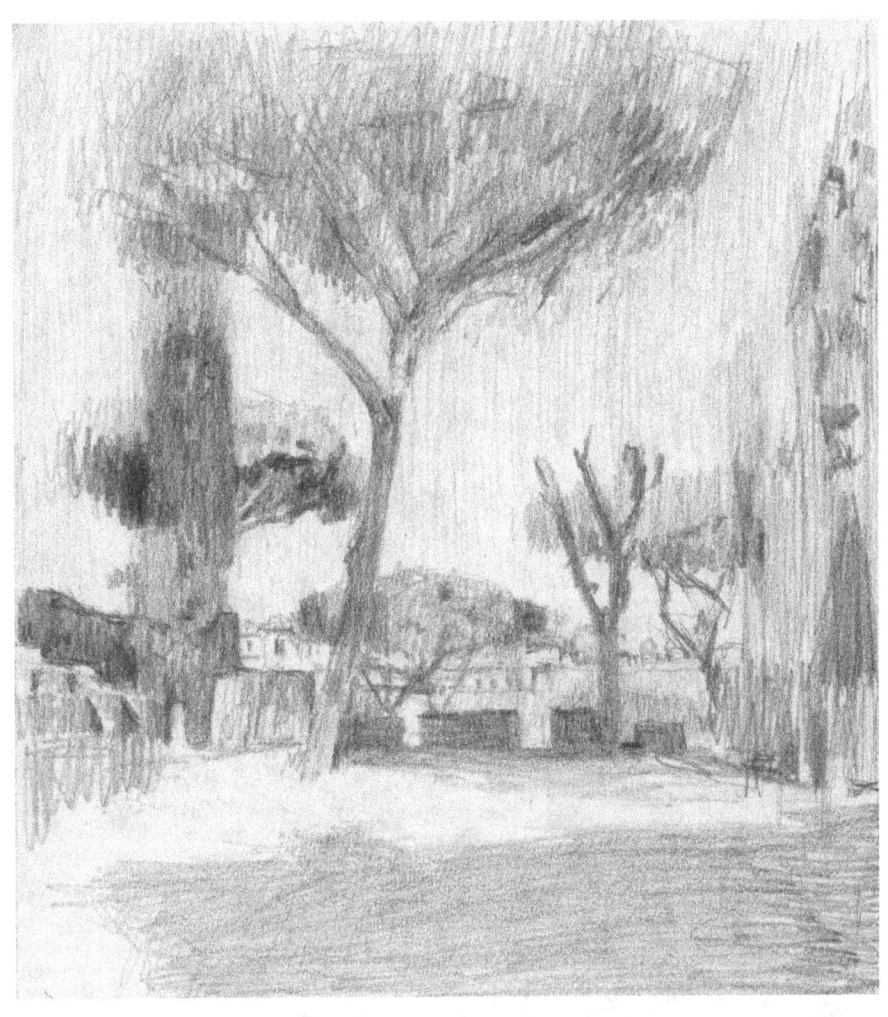

 In this spot, there was a group of students situated on the left and right sides both throwing small pebbles at each other, a mini-war of sorts. These kinds of games, spontaneously created, are some of the most fun parts of growing up.

 These silly, sometimes outright stupid games arise out of boredom, circumstance, or mere accident. Rules, if needed, develop very quickly and naturally. Unfortunately, these games tend to only exist in that moment, somewhat like a dream—you try to recreate them afterward but rarely, if ever, can the moment be duplicated.

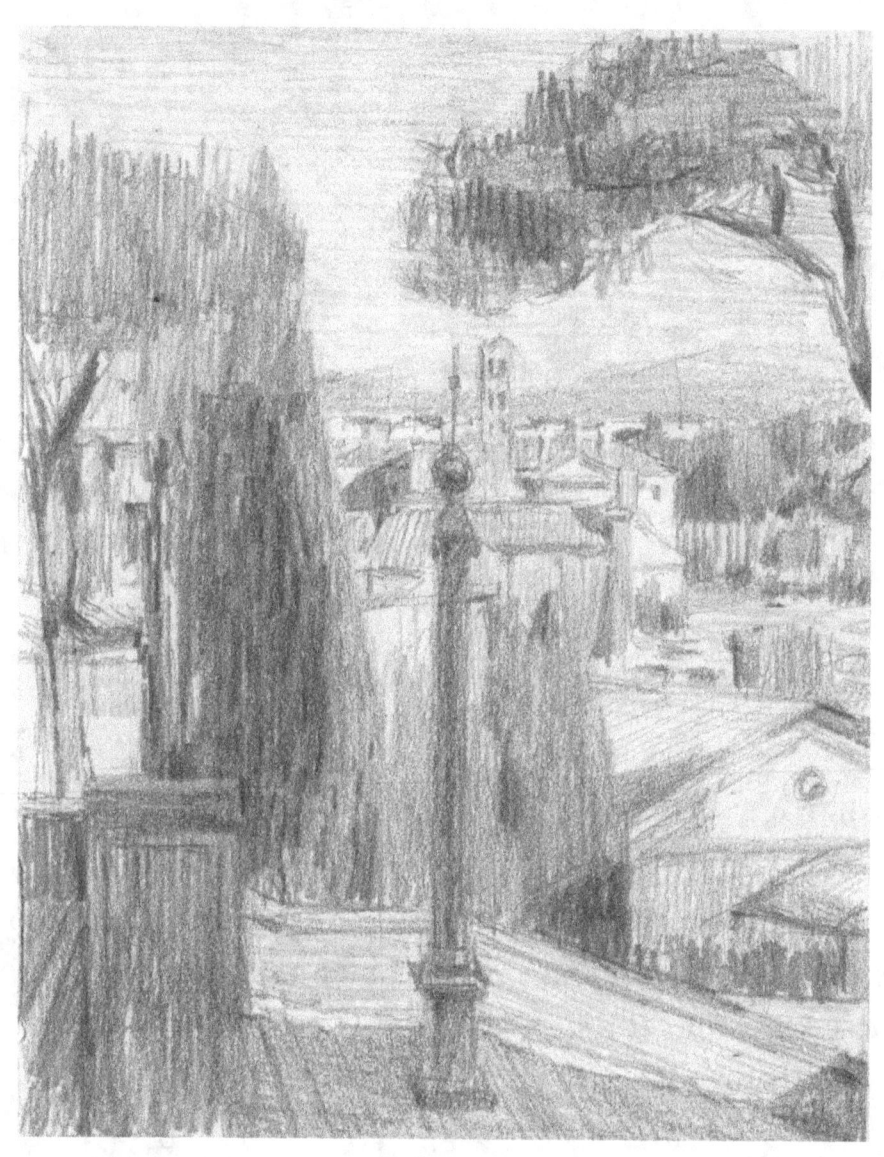

DAY VII

In addition to the 10 days in Rome, I reserved one day for an excursion to Florence via train, mainly to see Michelangelo's David, but also for a side mission–the movie *Hannibal* had some scenes filmed in Florence and I thought it would be fun to see them in person.

When I got off the train I headed straight to the museum where David was and to my dismay, there was a long line around the block. I was anxious to walk around and draw so I seriously considered completely abandoning the whole thing, but I stayed. The silver lining was that I met some nice people–a couple from France behind me and a couple from Brazil in front of me.

The couple behind me was nice enough to let me leave the line and walk around a bit, which I did twice. In both cases, I gave myself 20 minutes: 10 minutes of walking and 10 minutes of super-focused speed drawing; just outlines, no shadows. Nothing cuts through diddling around like having a time limit. When I returned to the line I finished the drawings from memory.

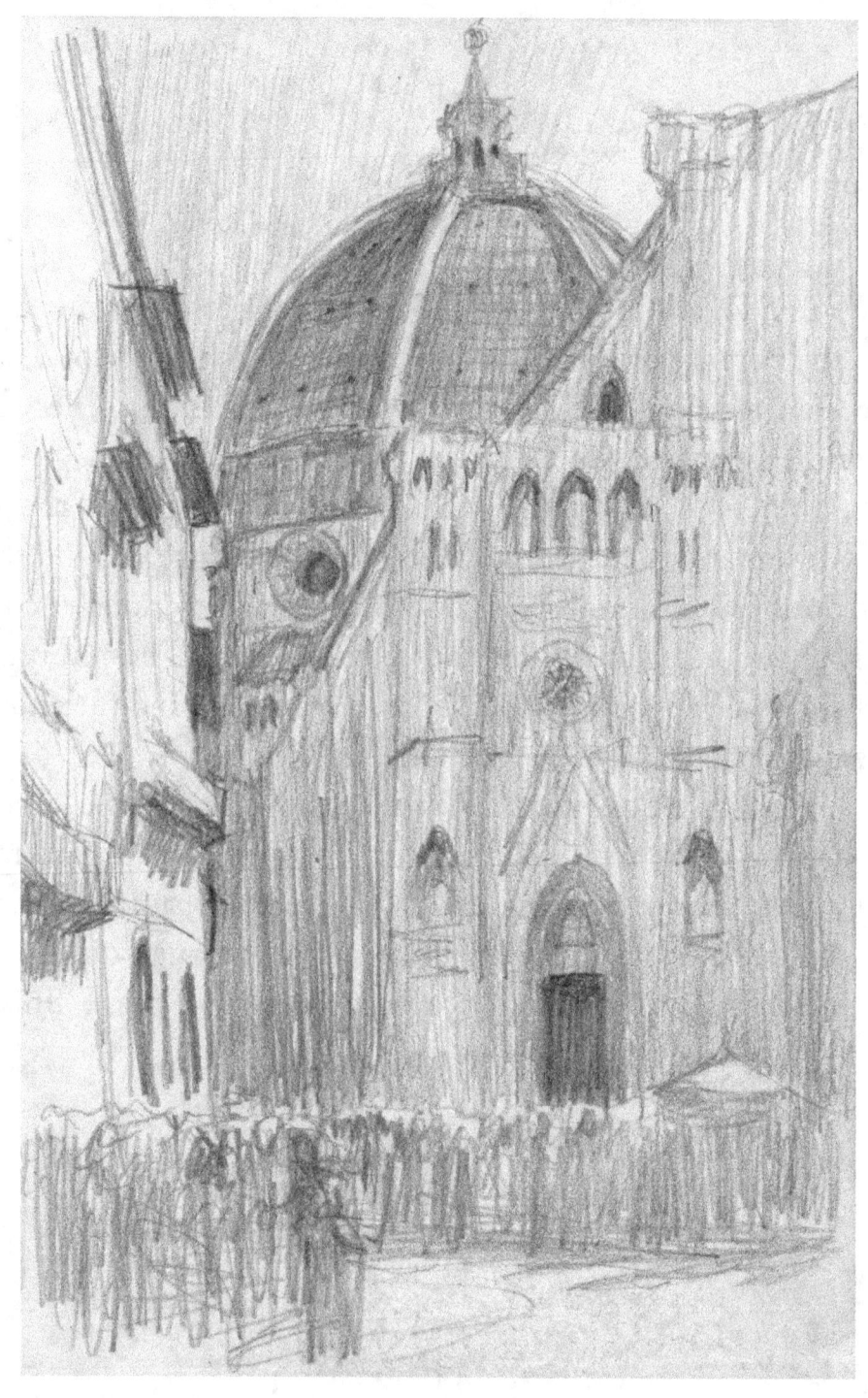

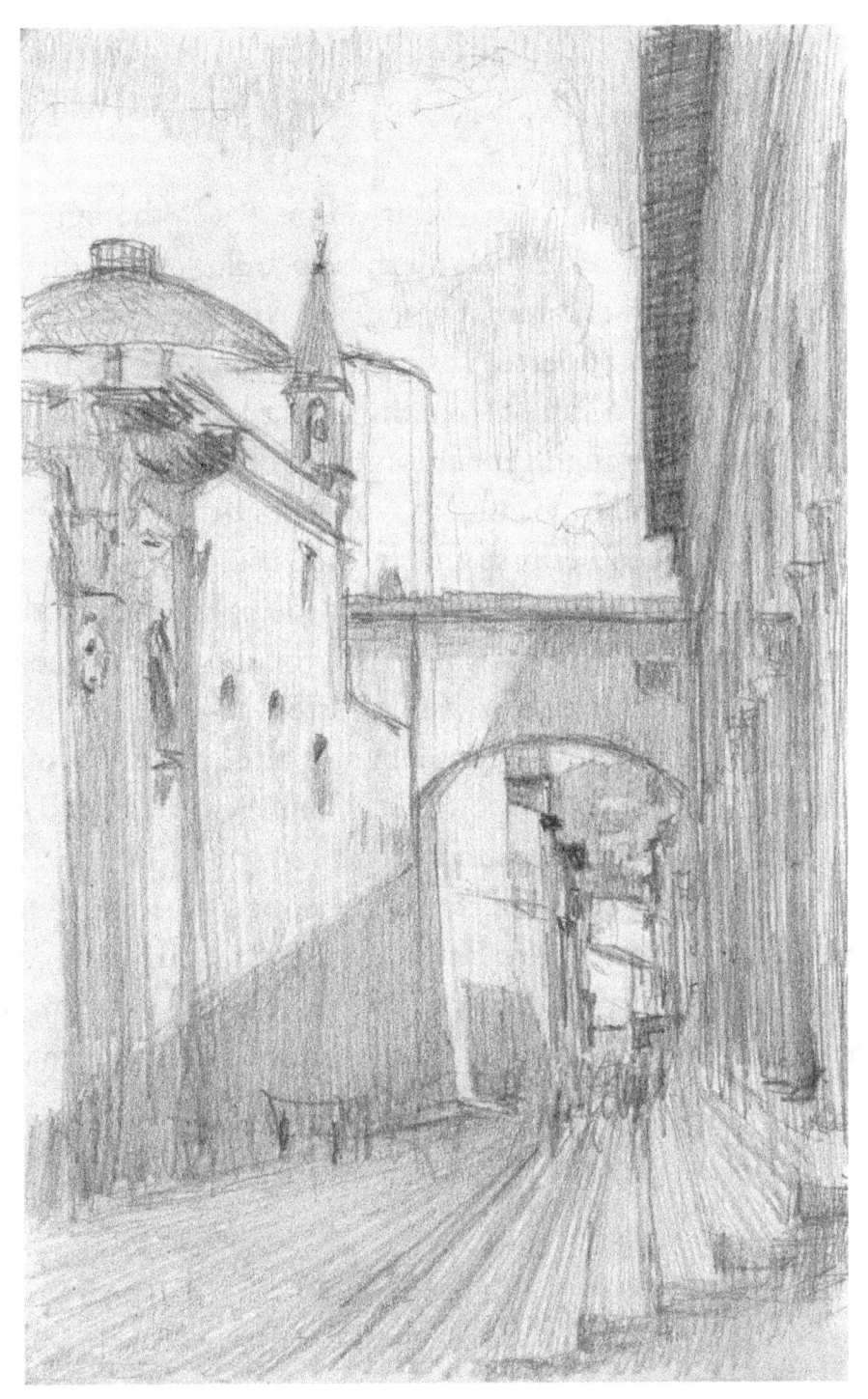

While waiting in this line, I thought of the person—Michelangelo, in relation to all these people waiting, day after day, year after year, to see his sculpture. I wondered what he would think of this if he were alive now. I wondered, is this the best we (as in, anybody who makes things) hope for—to make something that lasts? Not just physically, but in people's minds through generations. I think the answer is yes. At the same time, there is an odd dynamic at work—once something reaches this level of notoriety it becomes a spectacle, and thus you question people's admiration and interest in it. Do they want to experience the thing itself, or *experience the experience* of the thing? Maybe it's one, maybe the other, maybe both. For me, in this case, it was admittedly both.

I finally got into the museum and after walking around David for a bit, I set to picking a view to draw it from and started. There was a constant movement of people around David.

A kind of pseudo-sport has developed whereby people try to get a picture of themselves near these important and/or famous things within a reasonably short amount of time. There were also guided tours being given, which was fine by me since I gleaned fun information from them.

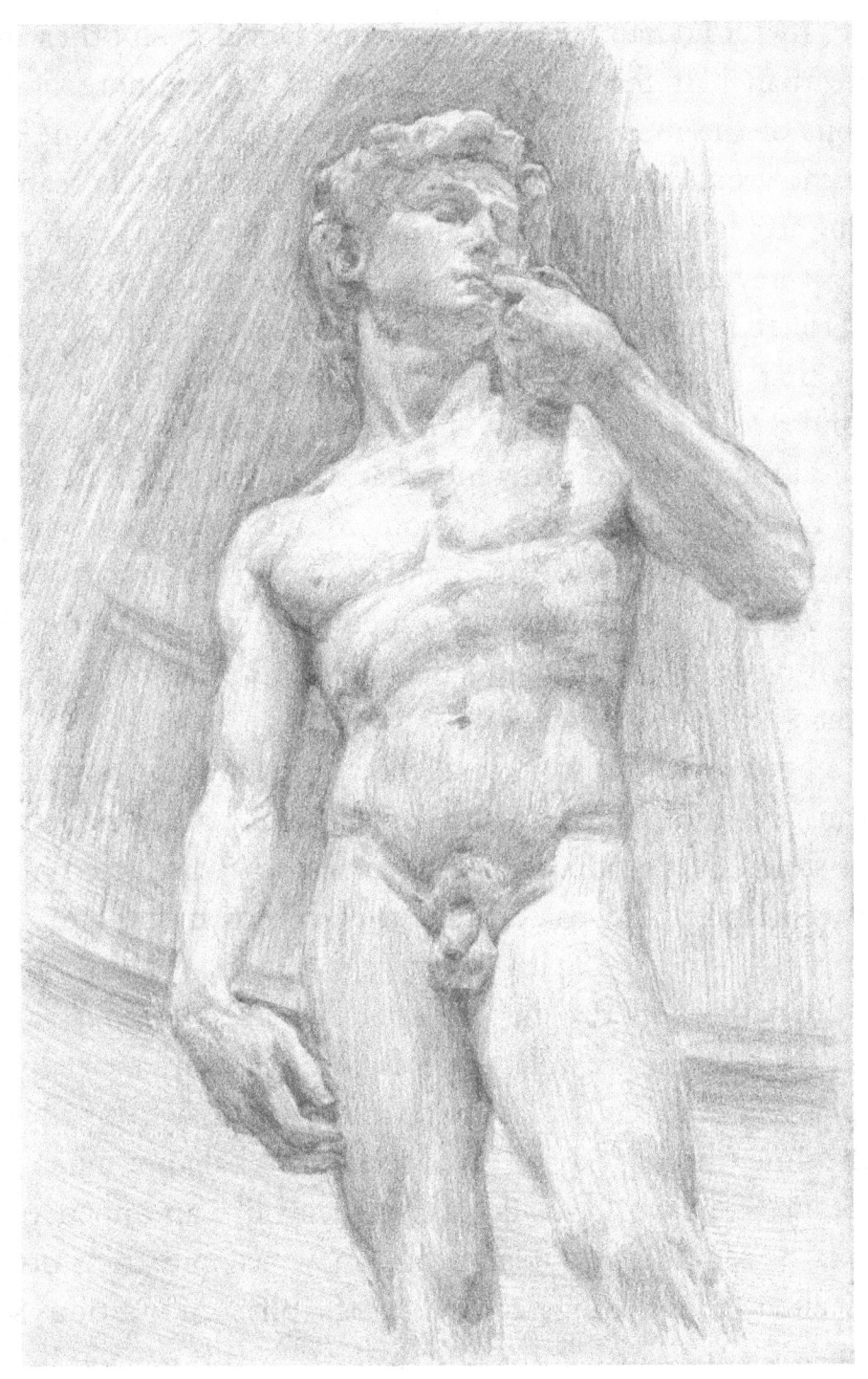

I wish I'd had more time to draw David from other angles but with more than half the day gone, I wanted to see more of Florence. Rushing out of the museum I "accidentally" stepped on some art prints placed on the ground by people selling them, but I quickly realized there was nothing accidental about this scam.

They told me to stop as one of them picked up one of the art prints and rolled it up, preparing to sell it to me. He explained that he can't sell it now that I stepped on it and that I have to buy it for 45 Euros. I declined and after much cussing on his part, he proposed 25 Euros. I asked him to unroll the print and show me what damage I had done by stepping on it. He unrolled it and arbitrarily pointed, but I saw no damage. I told him I didn't do anything to the print and he eventually gave up.

Again I wondered, what circumstances led to this lifestyle? The most forgiving answer would be starvation, but it's probably more nuanced than that.

I conveyed this story to a fellow traveler at the hostel. He knew of this scam and told me of a worse one whereby a bag he left with his friend was stolen by a group of young women who distracted him. Inside the bag was a laptop and passport; it took him 6 months to get a new passport.

I rushed on to find the spots where *Hannibal* was filmed. Finding the first one was exhilarating. It was a balcony near a plaza busy with people. Not that I'm special, but I'm betting that I was the only one there at the time who was paying attention to this balcony, much less knew the significance. The world inside of film seems like an impenetrable one. Scenes may be shot in real places but they become transformed into something else within the movie. Being at the physical locations somehow makes that world just a little more tangible.

DAY VIII

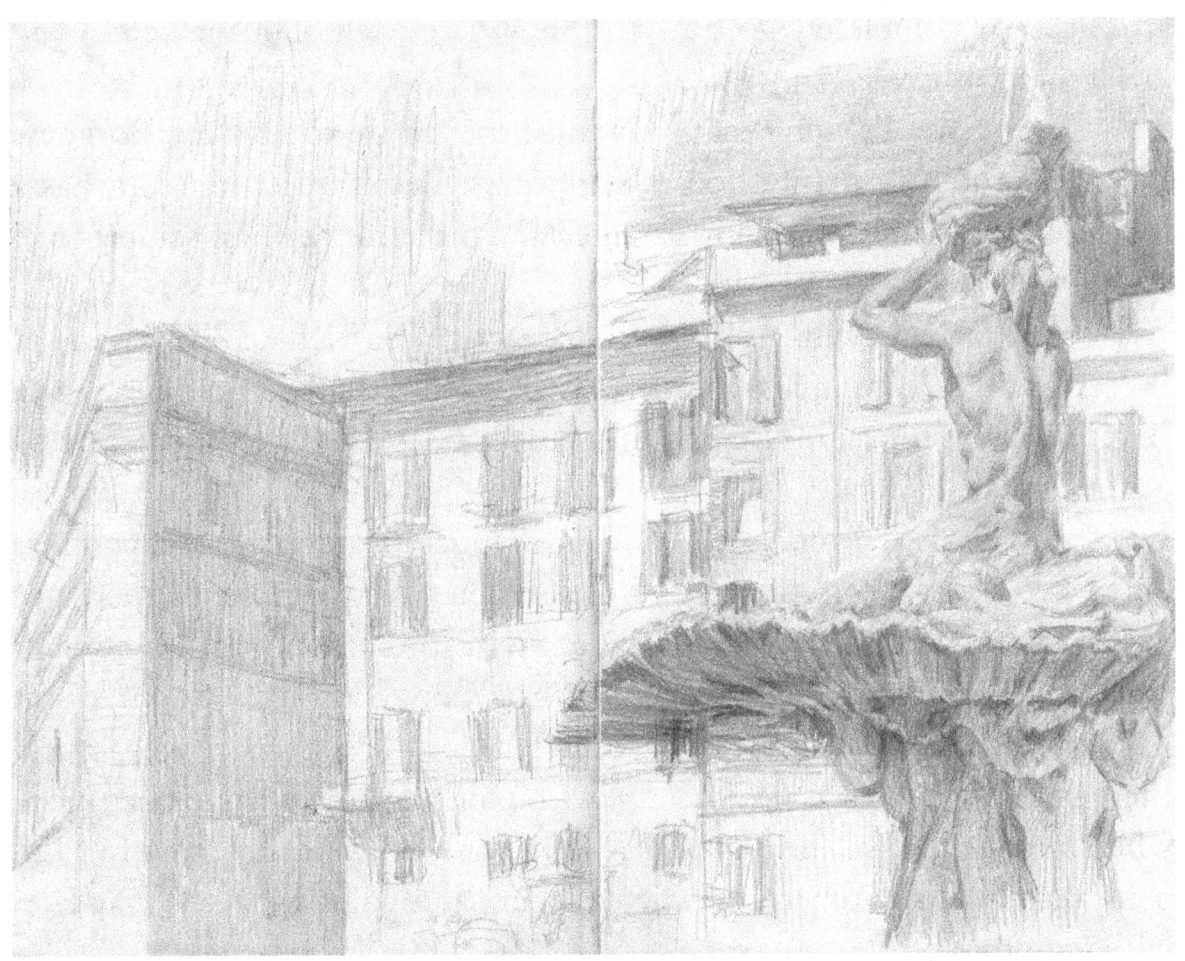

 I had seen this fountain sculpture some days before drawing it. I thought the figure in the sculpture was supposed to be drinking from a shell, something like Dionysus endlessly drinking wine, overflowing and pouring all over himself—a neat idea for a fountain. However, while drawing I overheard a tour guide nearby explaining that this figure, a Triton (a minor sea god), was not drinking, but rather was blowing the water upward out of the shell.

 This was initially disappointing, which happens with art sometimes. For example, you may like a song, thinking the lyrics are saying

one thing, only to find out later that the singer was saying something else. It's an interesting phenomenon–once you learn something about a piece of art you can't completely go back to the way you felt about it before you knew that thing.

After drawing that fountain I moved on to visit the Borghese museum, which primarily houses sculptures. Because the museum has a two-hour time limit, I quickly searched the place for the best sculpture to draw.

The drawing on the following page is a view of "The Rape of Proserpina" by Bernini. Just as with David, I wish I'd spent less time on one single view of this sculpture and drew other ones, but as I stated earlier I get in a trance-like state.

This led me to the notion that sculptures are perhaps more "alive" (in a way) than paintings. Because you have a different experience with every angle you view a sculpture from, there is no single moment where the viewer feels "this is it, *this* is the thing". As a result, sculptures have a dynamic quality to them that require viewers to move around them–something that is not the case with paintings. While one does move when looking at a painting (especially large ones), I generally don't feel I'm constantly missing something when looking at a painting in the way I do with sculpture.

None of this is to say that sculptures are better than paintings, or vice versa. They're merely different in how they present themselves, what they can offer, and how we experience them.

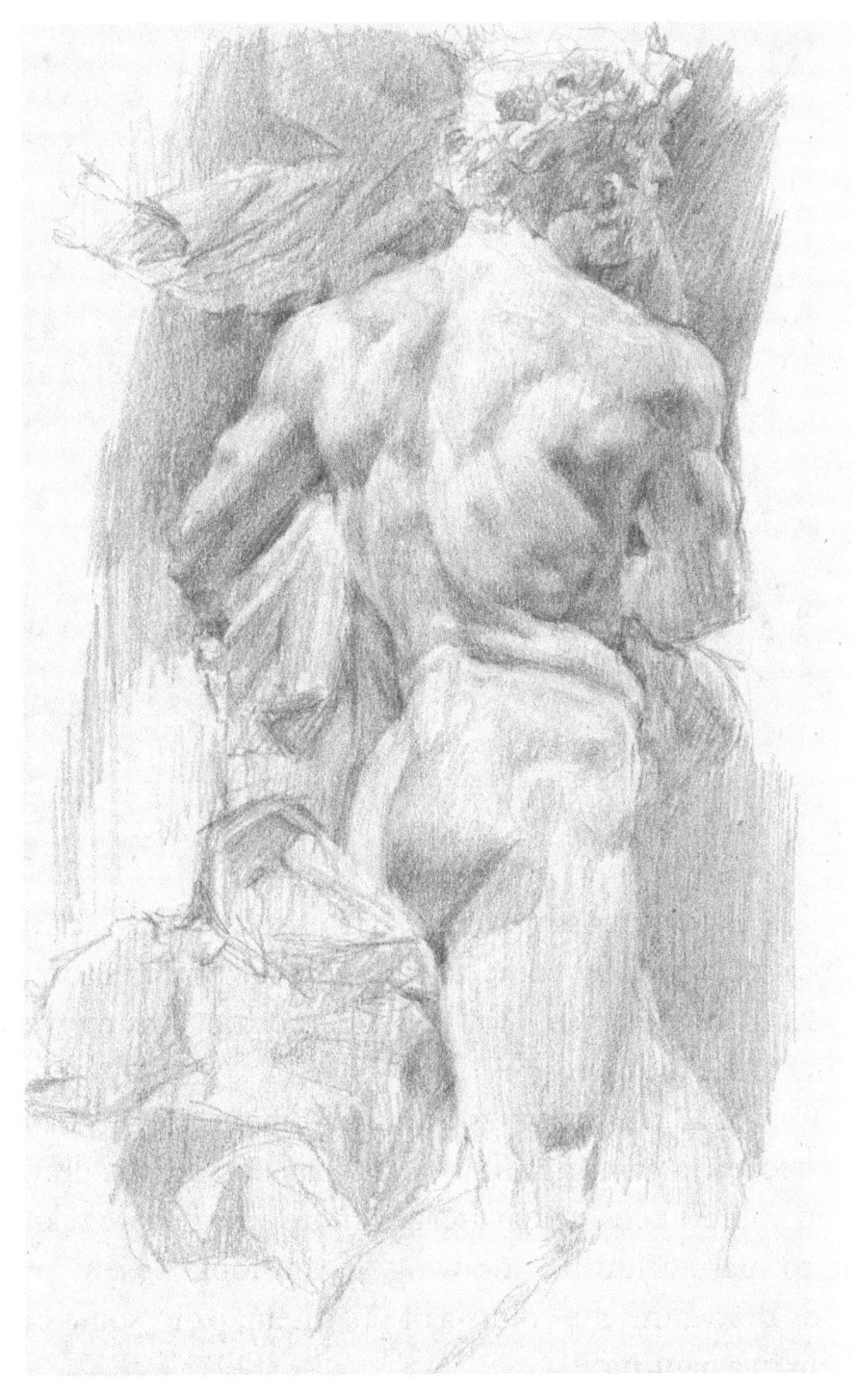

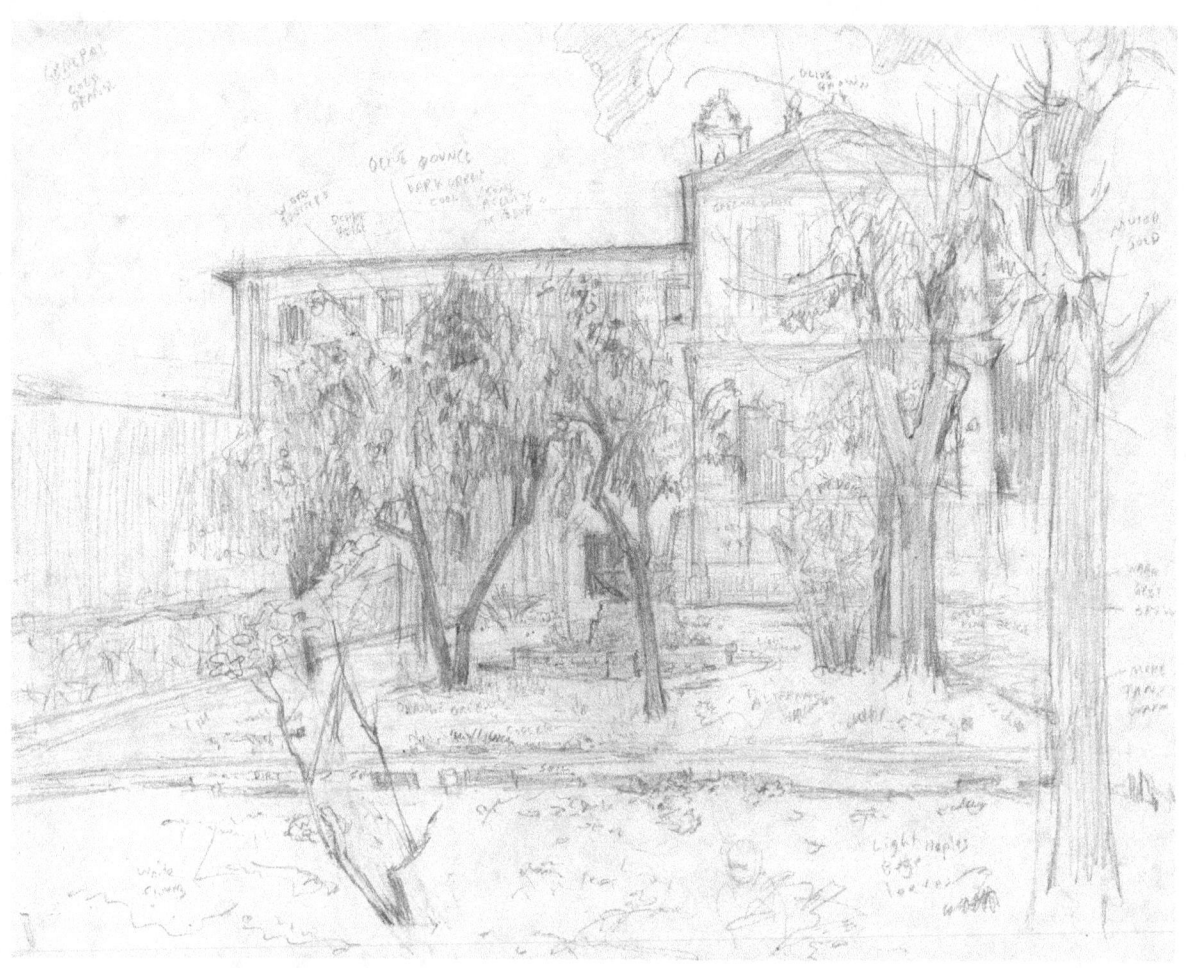

The sky was mostly overcast in this scene. This lack of sunlight made the local colors really come to life. In a lot of cities, overcast skies make everything look grayish. While there's nothing wrong with that, it was surprising to see the opposite effect.

Out of all the drawings I did in Rome, I felt this had the most potential to become a painting. This might explain why the drawing is less rendered and more like a schematic. It's more visual note-taking, rather than trying to make a finished drawing. If you look closely, you can see written words describing the colors as I saw them, or in some cases how I envision them in a painting..

This method is not unique to me. I was thrilled, and, somehow

comforted, to discover in a book on the painter Edward Hopper that he did the same thing.

It's a distinct collection of factors that lead me to make a painting. For me, color is a big factor. If a subject matter doesn't have an interesting color set up, often the drawing can say what needs to be said.

The scene in the drawing is the entrance to a college. It was behind a gate that opened at various points to let people in and out. I got a few suspicious looks from them as I moved around deciding what angle to draw the scene from. This happens regularly, and I understand why.

When I am looking at a scene to potentially draw or paint, it's not uncommon for me to be looking at private property. On top of this, all I am doing is staring, thinking, and pacing back and forth. From an outside perspective, I could easily appear to be planning a robbery.

Because of how peculiar I look in these instances, I've had the police called on me on two separate occasions. However, once people see me actually start to paint or draw, I'd venture it quells most, if not all, of their fears. Furthermore, I've sold several paintings to people who caught me in the act of making a painting of their house.

Short of holding up a neon sign explaining what I'm doing, there isn't much that can be done about it other than to be quick. However, this preliminary "looking" phase is very important and shouldn't be rushed.

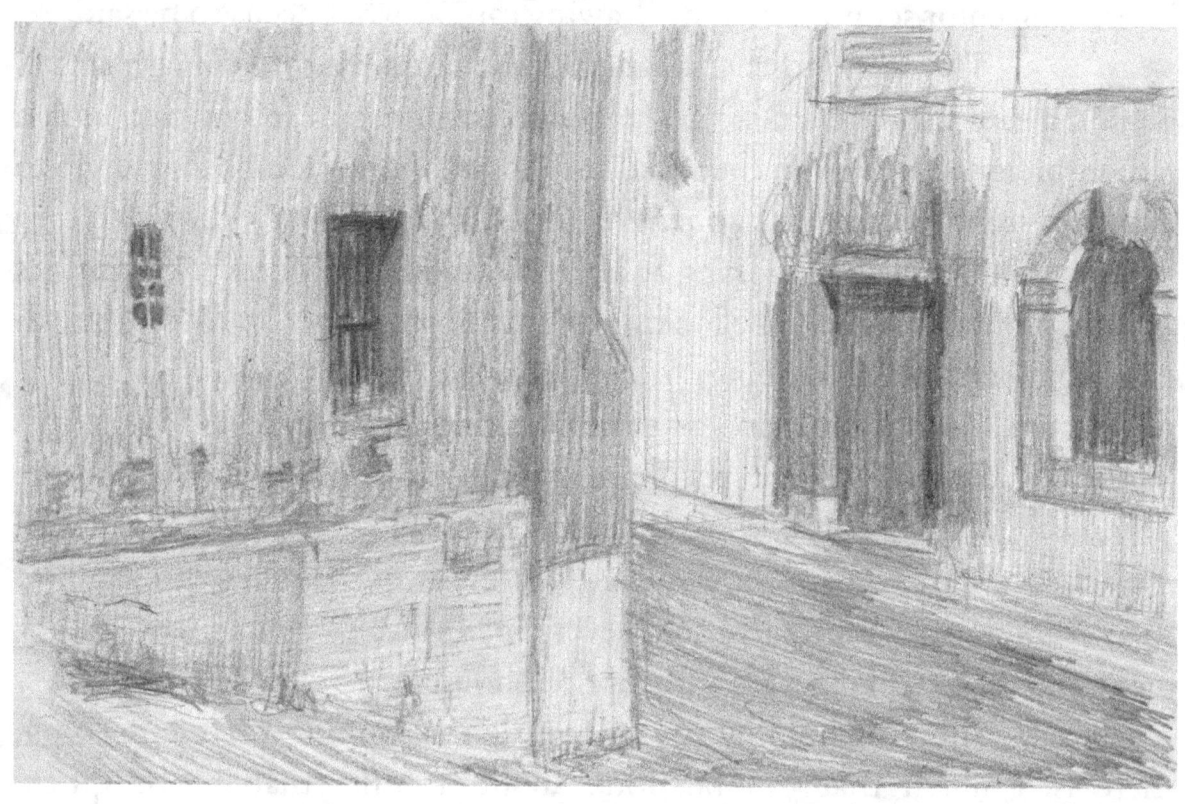

 I stopped here to rest without the intention of drawing. While sitting there, a young woman sat down several feet behind me and, of all things, started drawing in a sketchbook of her own. I figured "when in Rome…" and started drawing as well. I don't know what she was drawing, nor can I say if she saw what I was sketching, as she eventually left without either of us saying a word.

DAY IX

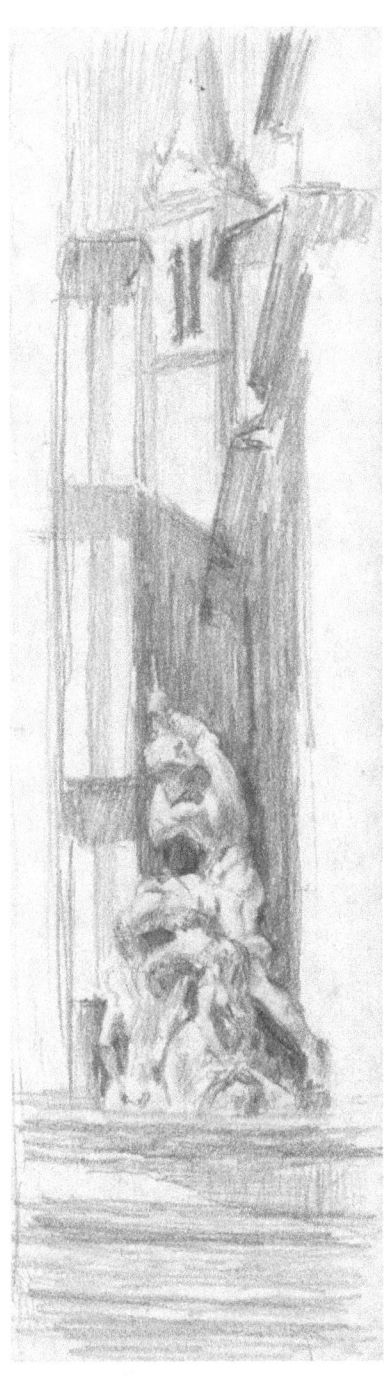

Another fountain sculpture. I was drawing this while standing close to a restaurant. A host nearby was trying to get people to come inside to eat–a fairly common situation in Rome, especially around tourist spots.

The prospect of doing that job for an entire day seemed horrendous. I am biased though, I am the opposite of a salesman; I am not good at it nor do I enjoy it. However, I noticed that in between trying to lure potential customers he was goofing around with co-workers, which is to say it's like any other job. Furthermore, this guy was generally jovial–more than me, certainly. He was making the best of it, which is what you have to do in life.

On the following page is another secluded alley. Just as I finished that drawing, a street dancing crew of three began to set up right where I was. The timing of my leaving and their arriving was so perfect that from an outside perspective it might have looked to be arranged beforehand.

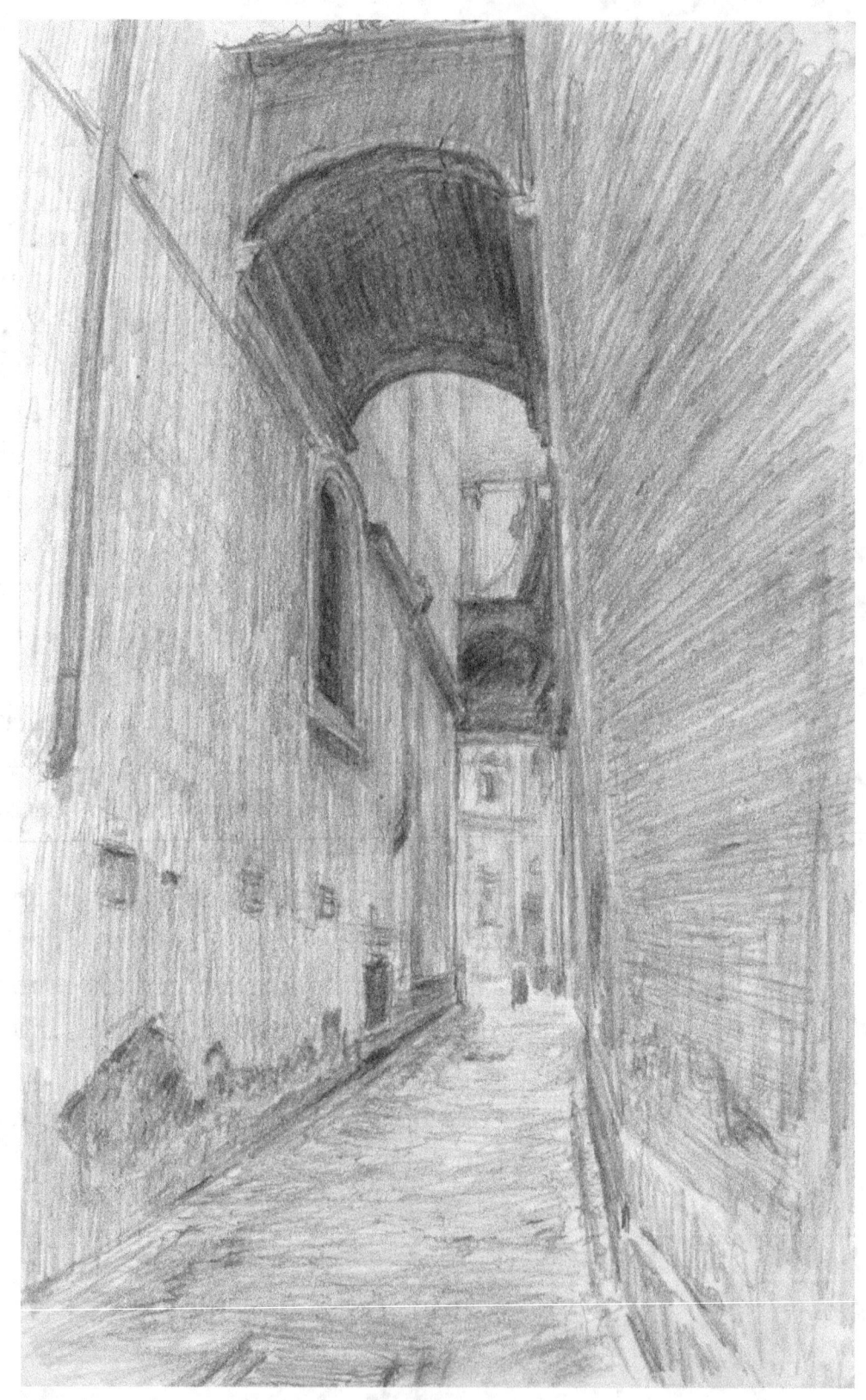

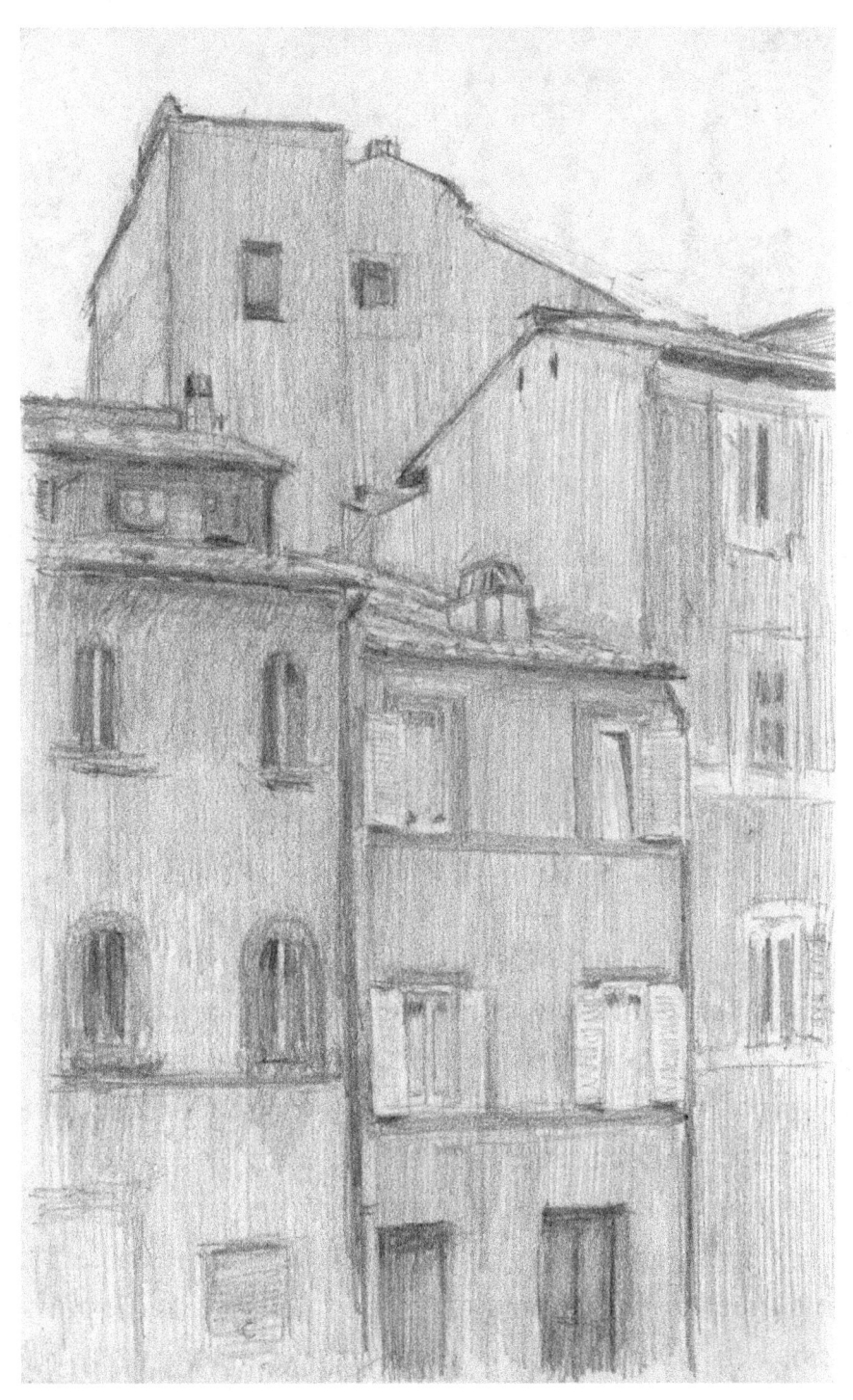

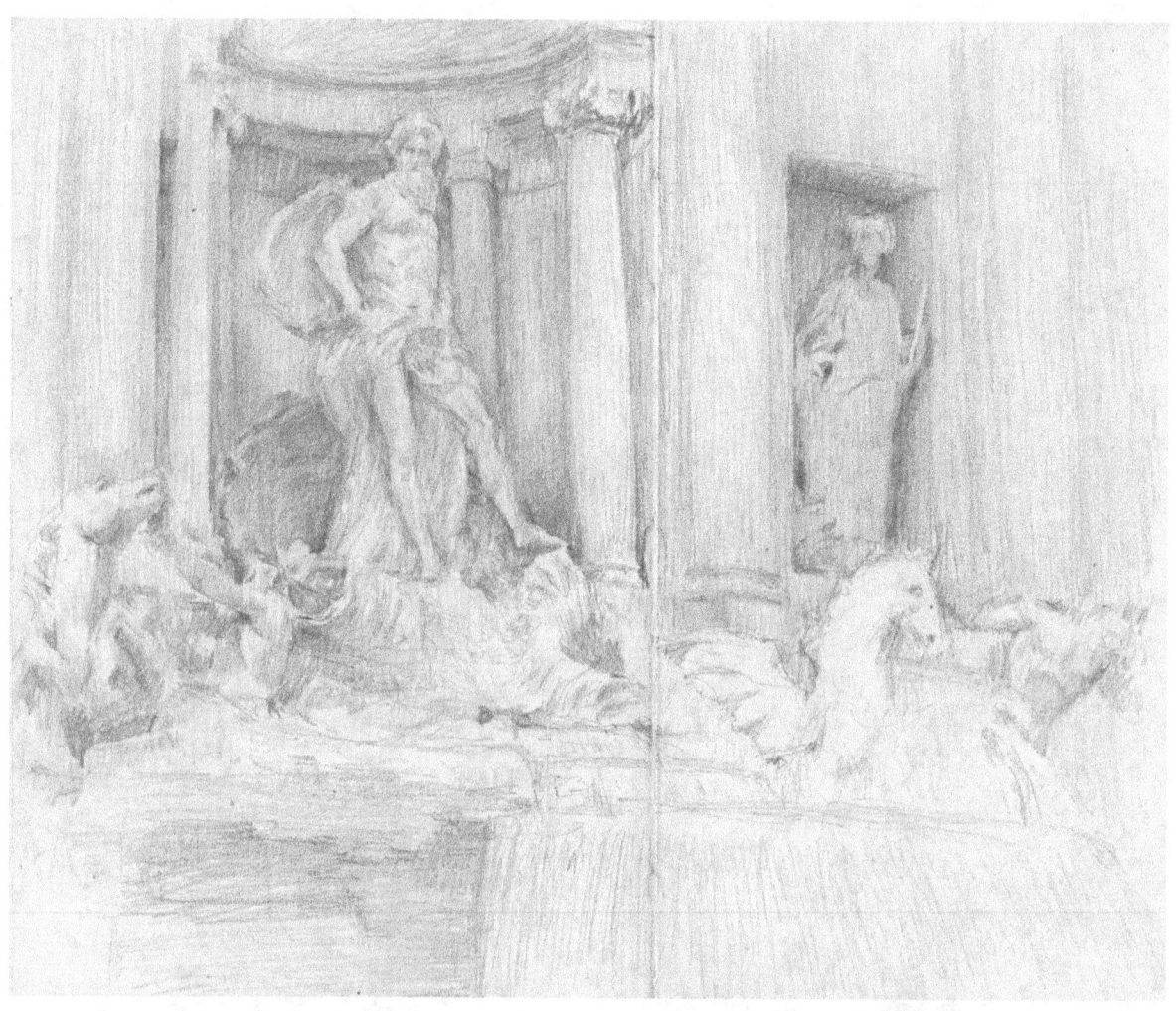

 This is a portion of Trevi fountain, a sight that is visually interesting *and* also happens to be a huge tourist attraction; I require the former for a drawing, but not the latter. I went there three times over the course of the trip and it was equally crowded each time.

 In the vicinity, there was someone begging for money. He had deformed legs, misshapen feet, and he sat on a wooden cart–something like the thing mechanics lie on when going under a car. He pushed himself using his arms behind him with his hands stuffed inside worn boots.

DAY X

It's interesting how context changes things. I had to take the bus to a museum and I was concerned about the tickets I purchased the night before and if they were going to work. When the ticket worked I was elated to merely take a seat. The mundane act of taking a bus ride, something I might consider a hassle back in the U.S., became a joy in this foreign land.

I had a similar moment when I accidentally got off the train back from Florence a stop too early. Fortunately, the hostel was only 45 minutes by foot, but I was able to get a ticket for the Metro (underground train). By the time I got on the train, I felt the same as on the bus. Buying tickets for buses and trains are far from major accomplishments, but *contextually* I was excited, a little proud of myself, and relieved. There was a loud screeching metal noise as the train rode from stop to stop, but it was music to my ears knowing that I was navigating my way home.

In these scenarios, along with less exciting moments throughout the trip, I felt grateful. I was grateful to walk, certainly grateful for agreeable weather, grateful to avoid being scammed, grateful to meet and talk to other travelers in the hostel, grateful that my plans generally worked out, and grateful to be in Rome. I wondered though, do I need to be grateful *to* something? Does gratefulness need a "target"? I feel that if there is some force responsible for the thing I'm grateful for, it's also responsible for the opposite. At the same time, "grateful" is pretty much the same as "thankful", so it seems odd to feel thankful without something or someone to feel it *towards*. What I've come to is that it's a good feeling and it's best to simply feel it, rather than try to make sense of it.

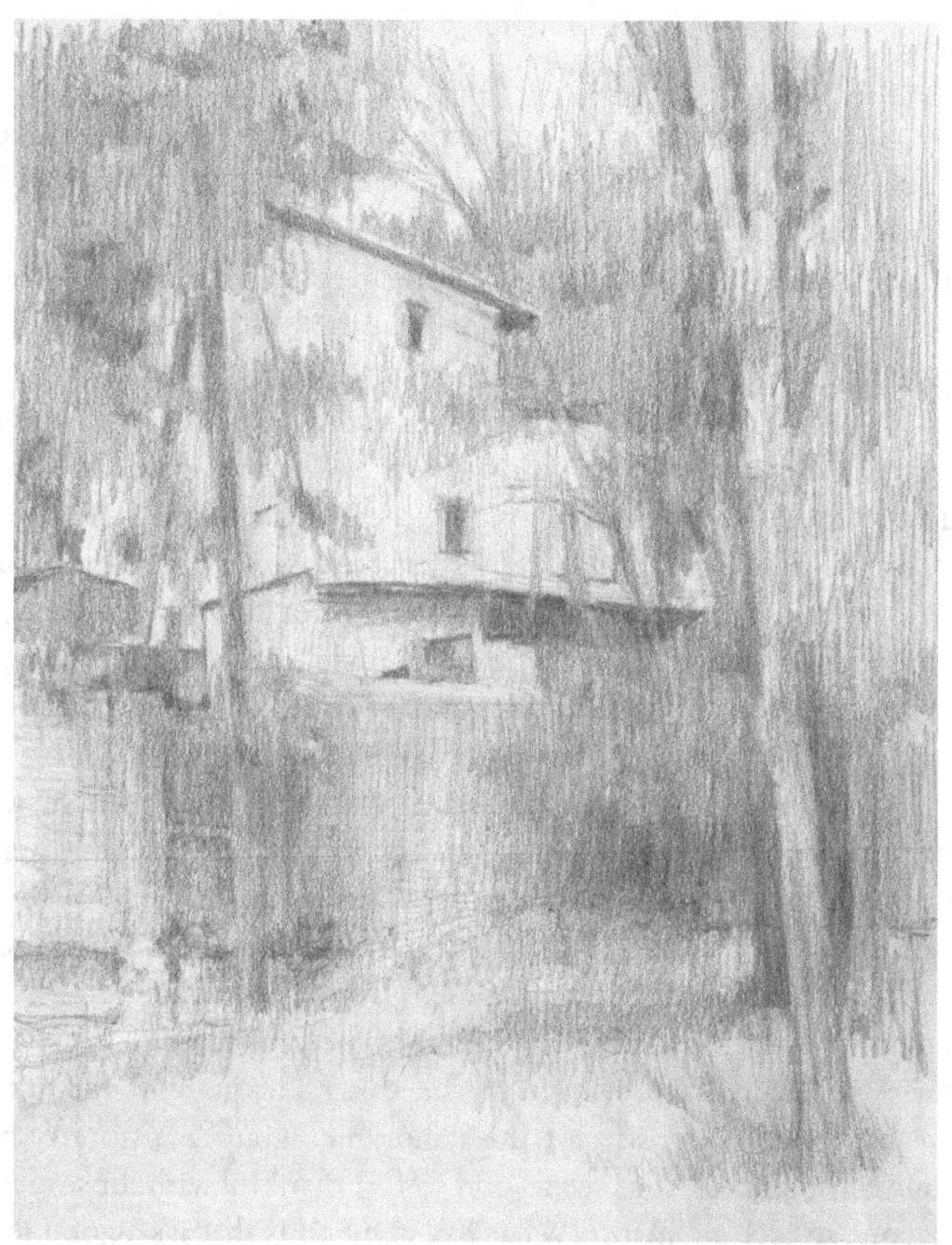

On the way to a museum, I went through a large park area and stopped to spend some time drawing. After days of walking around the city streets, it was nice to be in nature.

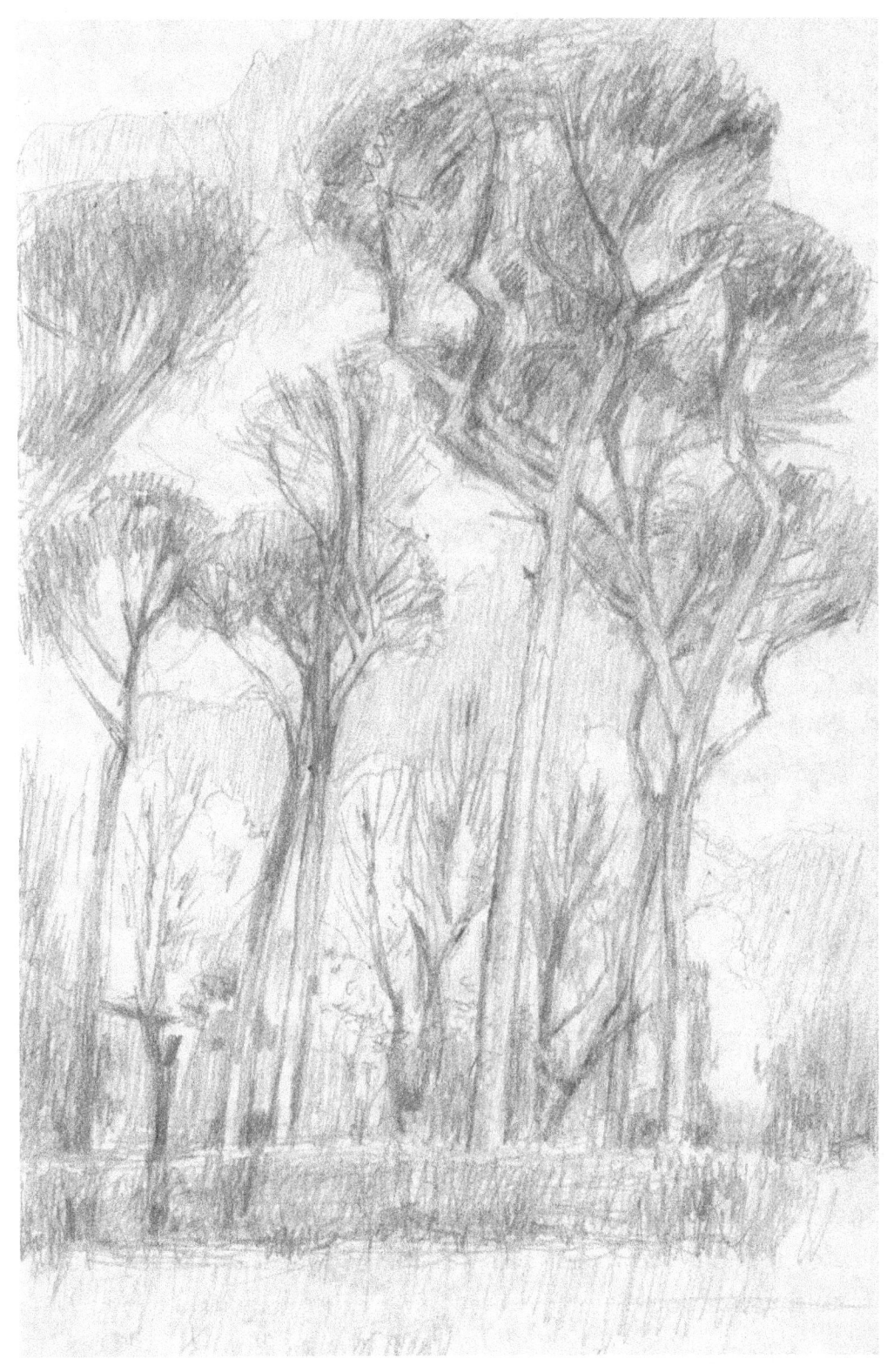

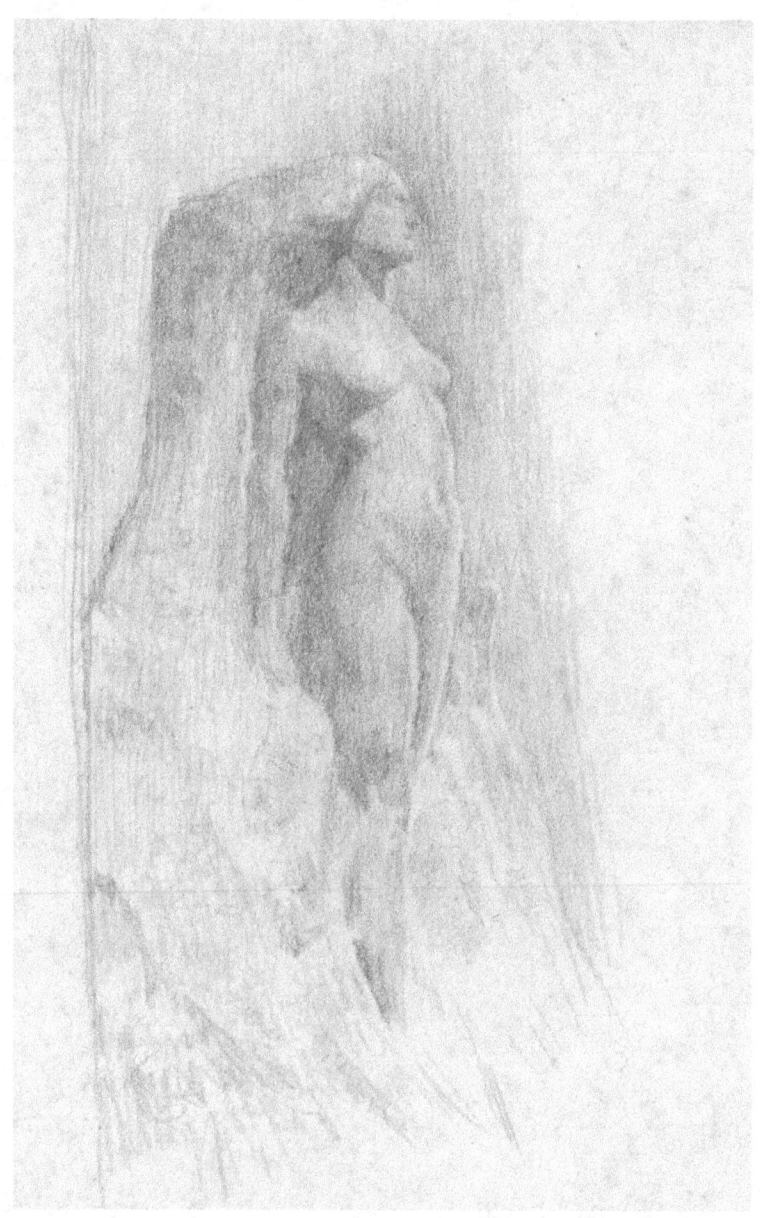

 This sculpture was inside the museum. I don't know if the artist intended the woman to be emerging out of the stone in this ethereal manner....or if the piece was simply unfinished. Whatever the intention, it made for a mystical look.

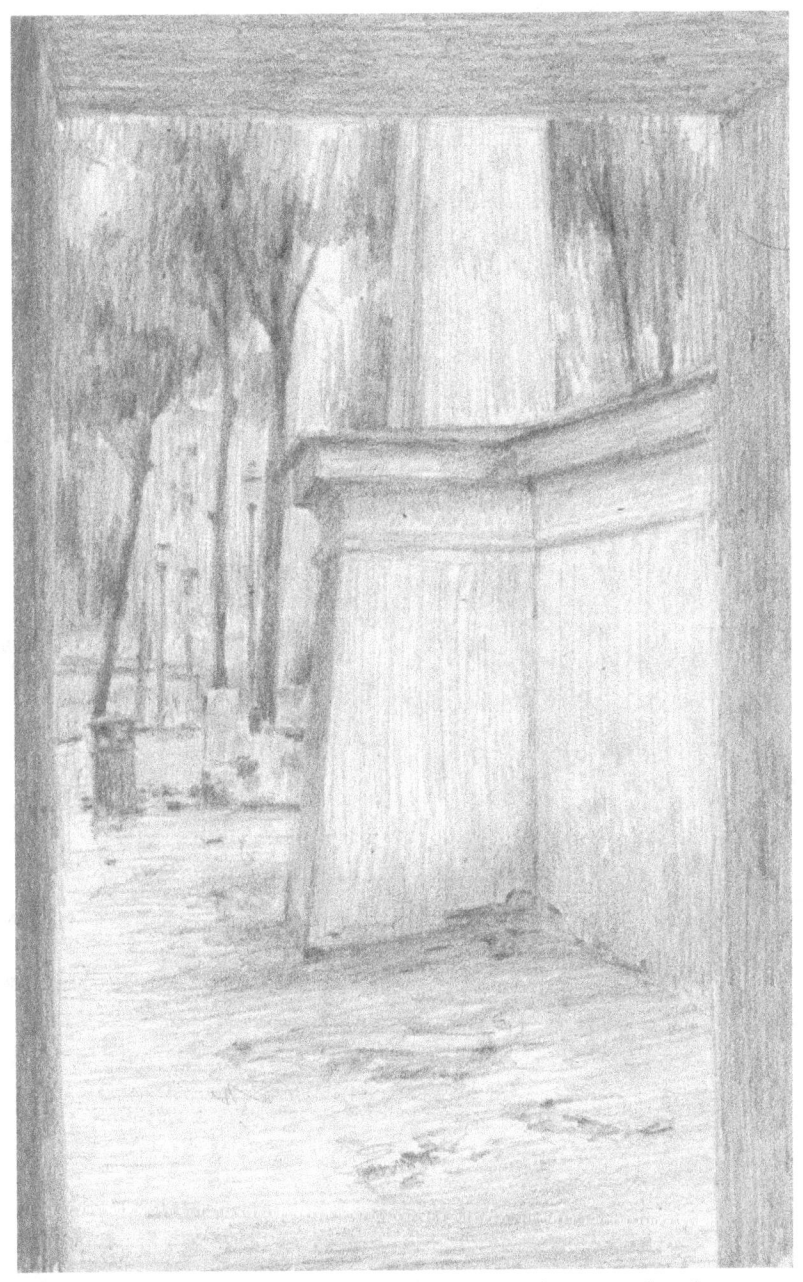

It was raining and I stopped underneath this stone structure that had benches and was sheltered. I ate lunch there and drew. The scene wasn't exciting really but it was there and it was something to do. Quite a large portion of "art" I've made is rooted in that impulse–that is, it's "something to do."

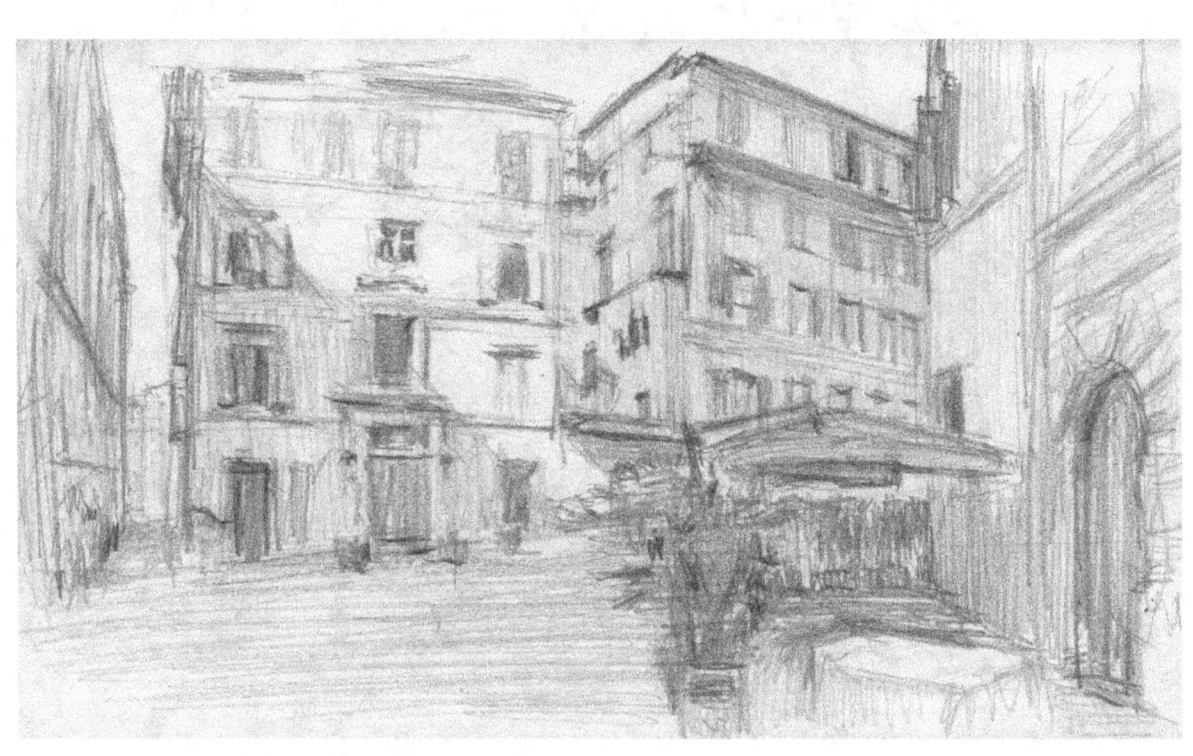

DAY XI

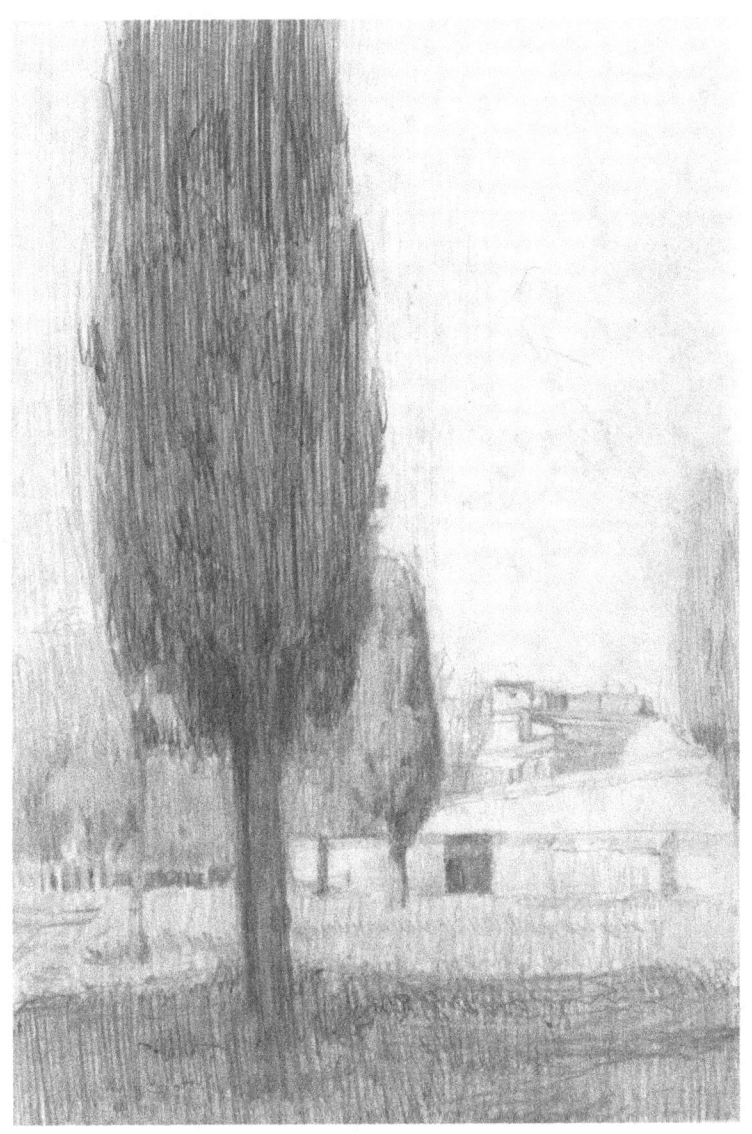

Walking through a park, I paused to draw. Across the street, a fight broke out between two homeless people. It looked like one was trying to grab something from the other. Other people were trying to break it up but they continued fighting and yelling at each other until the police showed up.

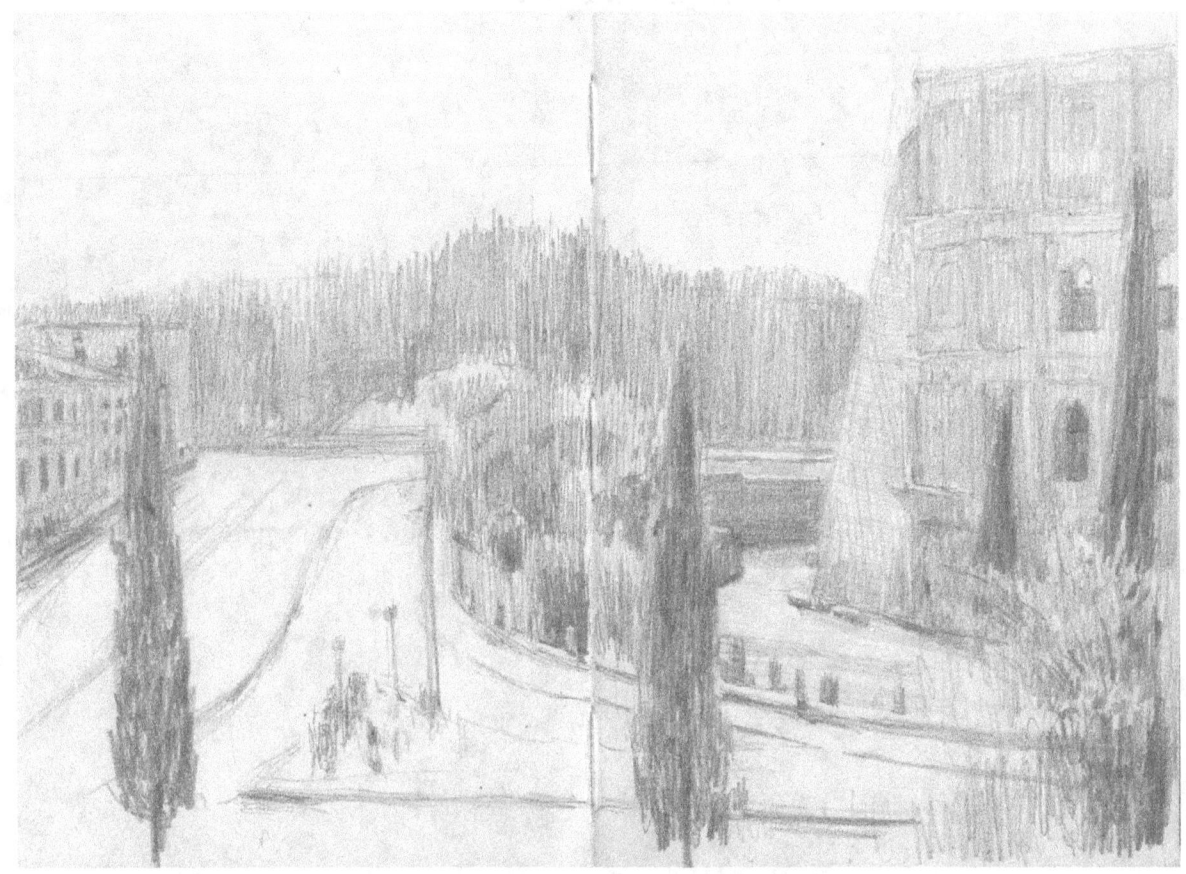

 This was drawn from a public basketball court; a portion of the Colosseum can be seen on the right. The thought of being a kid growing up here and casually playing basketball with the Colosseum nearby is pretty wild, but with time I suppose everything becomes normalized.

 The trip had caught up with me soon after this. I was exhausted. It was the last full day in Rome and it was a warm and sunny one. I wanted to take advantage of it but I just had no gas left in the tank. I lay down on some long stone steps, using my sketchbook as a mini-pillow. I was a little worried about how weak I was but it was simply that my body was tired. I got back to the hostel at about 4 pm and stayed in bed for the rest of the day.

DAY XII

My return flight to the US was to New York City where I grew up and my parents live. I was to stay there a few nights before taking another flight back to California. While on the bus to the airport I was notified on my phone that my flight had been canceled.

It was a stressful two-hour process but the airline was able to get me a flight the following morning and I would stay at a hotel by the airport. While the process of rearranging flights was unnerving, after it was all settled I enjoyed staying at the hotel. Though I do like meeting people at the hostels, it was nice to have one night in a room to myself. The hotel also provided a free dinner. It was in a dining hall filled with round tables like you see at a wedding and all the people from the canceled flight were there.

I sat down with people that I had talked to previously while waiting in the line at the airport. I listened to their stories and ate fish, potatoes, and rice, buffet style. I enjoyed talking with them and I wanted to hear more stories. I actually wished all the people rotated table positions every 10 minutes so I could hear everyone's story–something like speed dating. While I was having a fine time, I know this situation was more serious for others. Somebody I spoke to at the airport was worried about losing his job. For myself though, this was the best outcome I could have hoped for.

POST ROMA

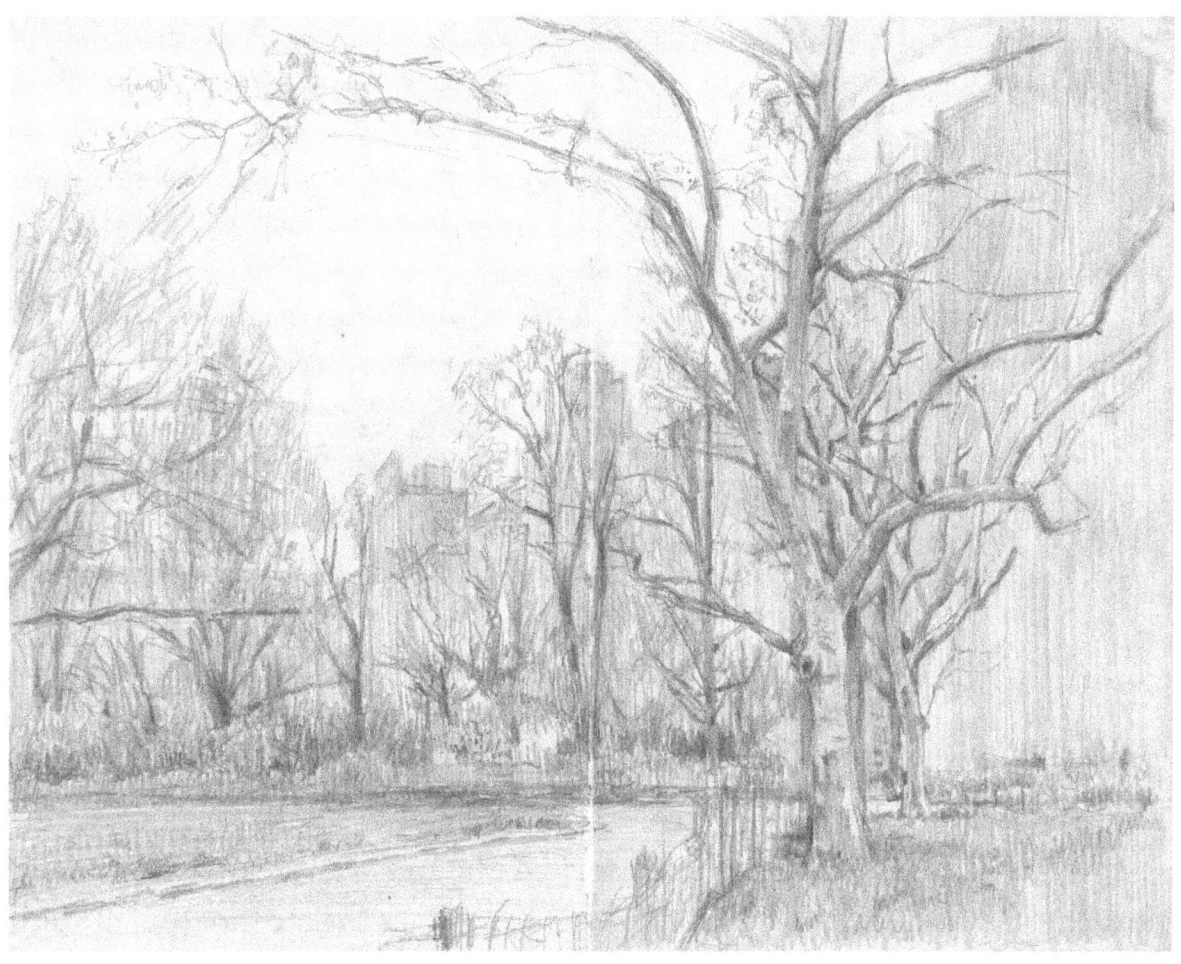

 Central Park in New York City. It really is a bizarre thing how you can be in one country at the beginning of the day and then another later on. Flying is obviously not teleportation but it feels in a way like you'd gone through a portal, and other than the time you spent on the plane (sometimes sleeping), you effectively had.

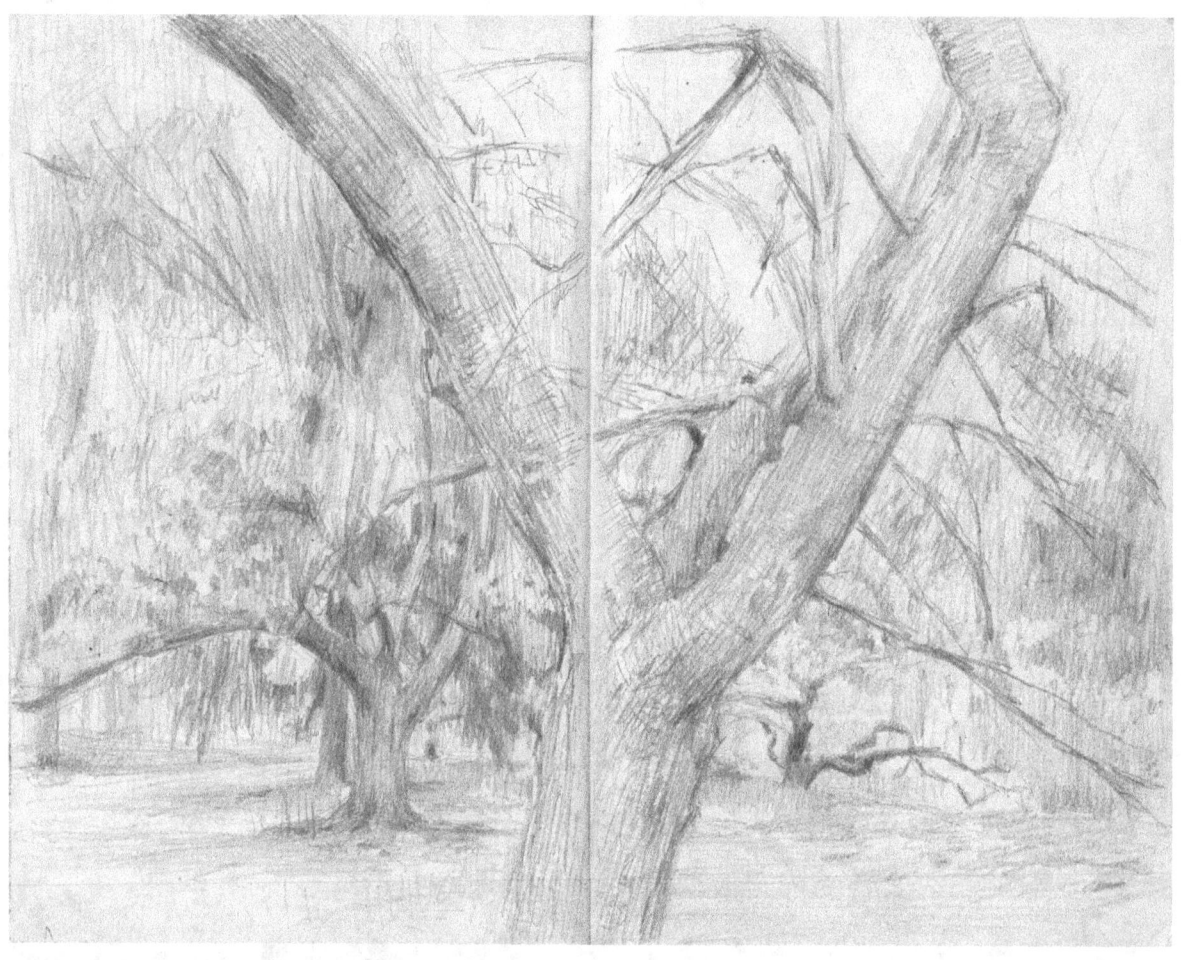

It was overcast when I started the previous drawing, but over time the sun came out. It was very pleasant weather for meandering around the park.

Trees are in a way the Alpha and Omega of subject matter for outdoor observational drawing/painting. They are the first things that most obviously stand out when we walk outside on planet earth–even in an urban setting filled with buildings, they still hold their own. Children often draw them, while at the same time mature artists are endlessly fascinated with them. They are at once both overbearingly commonplace and bizarrely unpredictable.

The trip went as well as I hoped it would, this includes all the mishaps. That saying "It's not an adventure until something goes wrong" was a recurring thought when things went awry. Fortunately, the things that went wrong were not too serious, and in some cases bore fruit.

Rome is going to be a hard place to beat with regard to its density of astounding sights. You need only walk a few blocks in any given direction before you see something, that, if it were in any other city would be the main attraction.

As remarkable as those things are, they're only a part of traveling. The things that I tend to remember are smaller, less remarkable moments that pop into my head years later. Eating a sandwich in a secluded narrow street. Waiting in a tunnel for pouring rain to die down as a sports team walked by, loudly singing in unison in Italian. A woman in the hostel common area microwaving me some leftover pasta before I left for the airport shuttle.

In that same hostel, there were two people staying in my room–one of them a Brazilian born man from Germany, the other a Russian woman. We all introduced ourselves to each other and tried to communicate as much as we could through the language barriers. The man had an acoustic guitar with him and we each took a turn playing a little. The man played while singing in Portuguese and the woman played while singing in Russian. As she was doing so I was sketching and thought, this is the stuff. You can plan to see the Vatican, David, the Colosseum, and you will see those things, but you can't plan *this*.

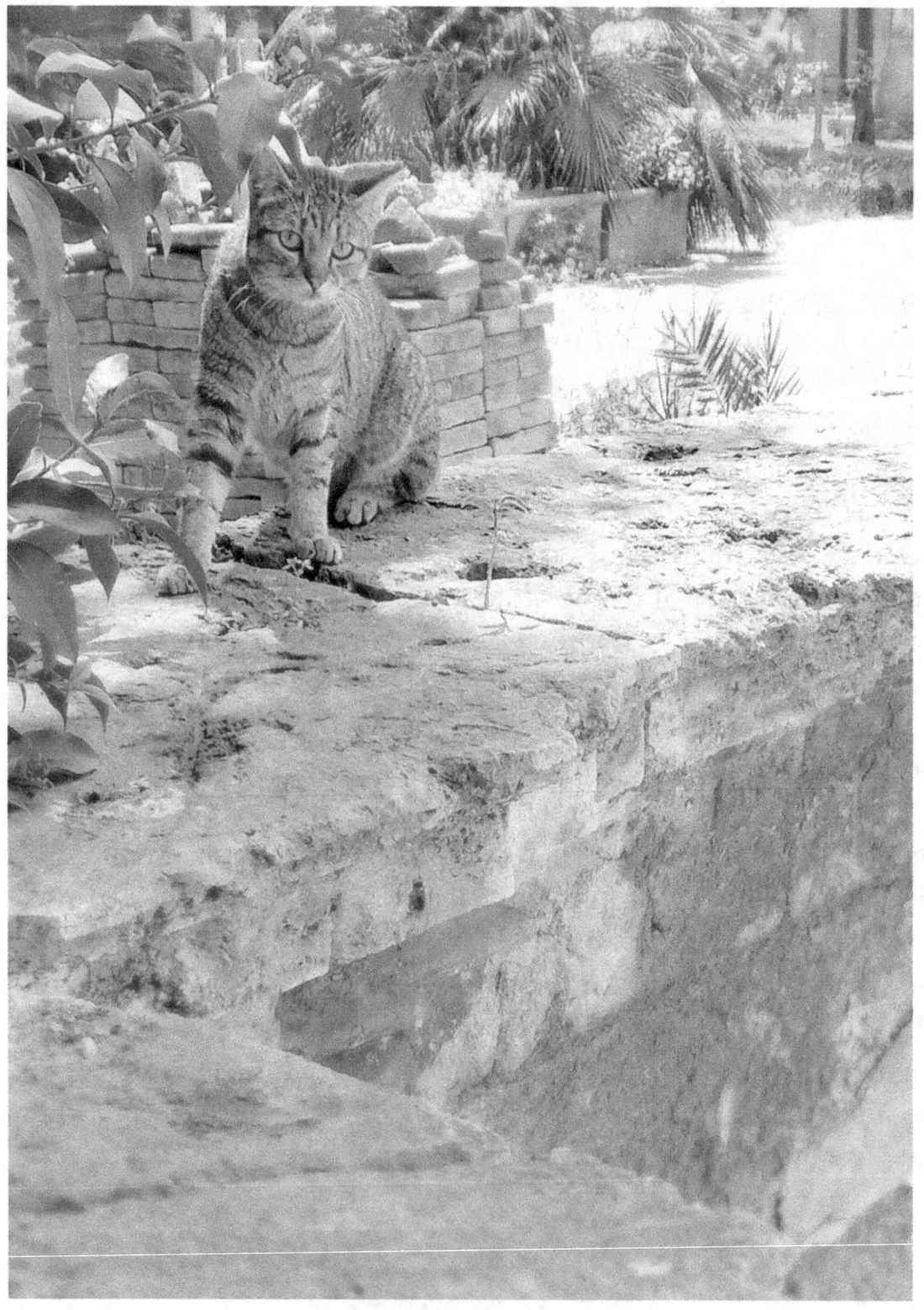

About the Author

Ari Targownik is a New York City native who found a passion for drawing at a young age. This led him to pursue art at LaGuardia High School. He continued his education at Pratt Institute in Brooklyn where he studied oil painting and received a Bachelor's degree in Fine Art.

Taking those skills, he moved to California to enter the video game industry. There he joined a game studio and worked for over a decade producing 3D graphics, concept art, and illustrations. Over the years both his fine art and digital art have informed each other in the creative process.

Ari is currently living, drawing, and painting in the Bay Area of Northern California.

Website: www.aritopia.com
Instagram: @aritargownik

Photo by Romel Revollo

www.ingramcontent.com/pod-product-compliance
Lightning Source LLC
Chambersburg PA
CBHW081459220526
45466CB00008B/2714